ESTELLE THOMPSON

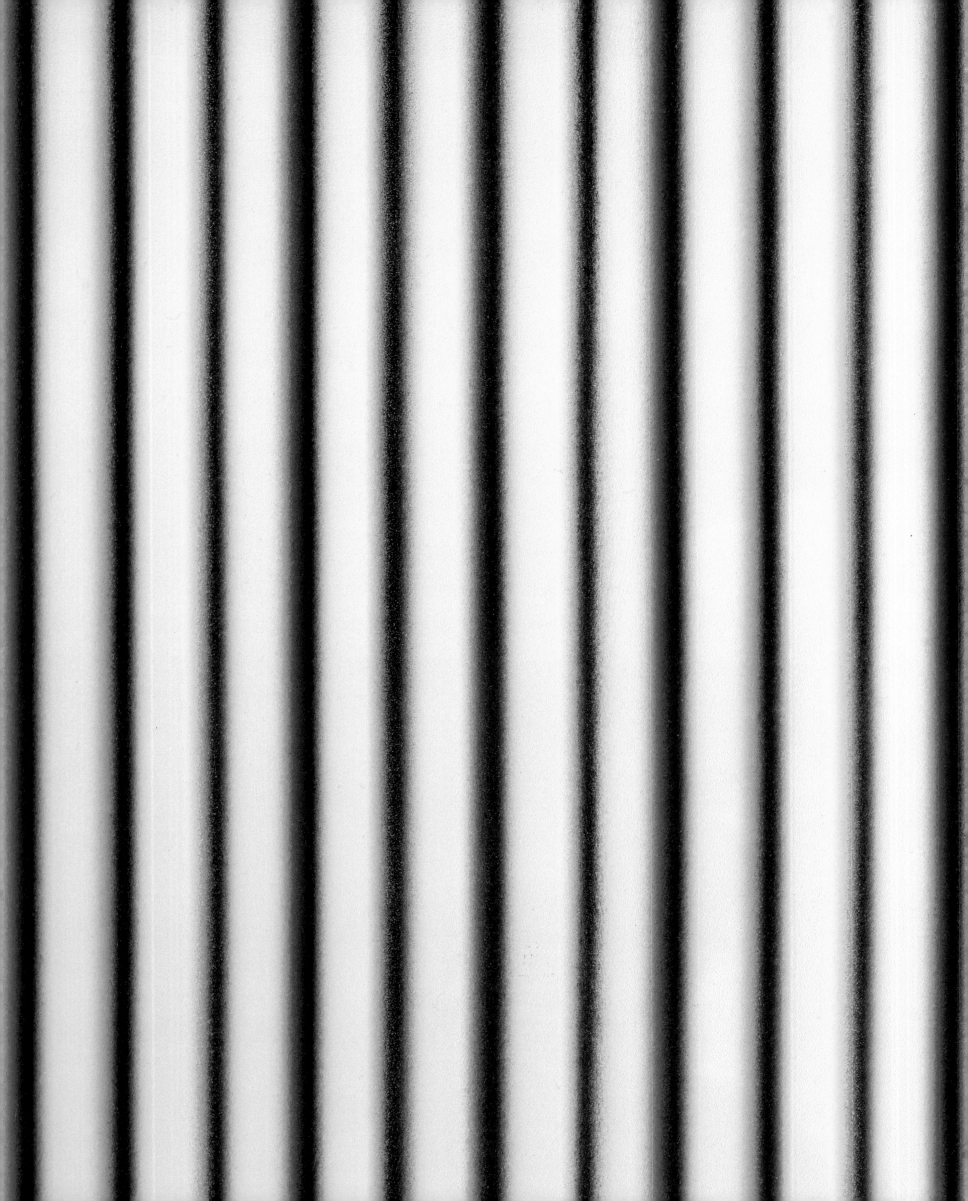

ESTELLE THOMPSON

MERRELL

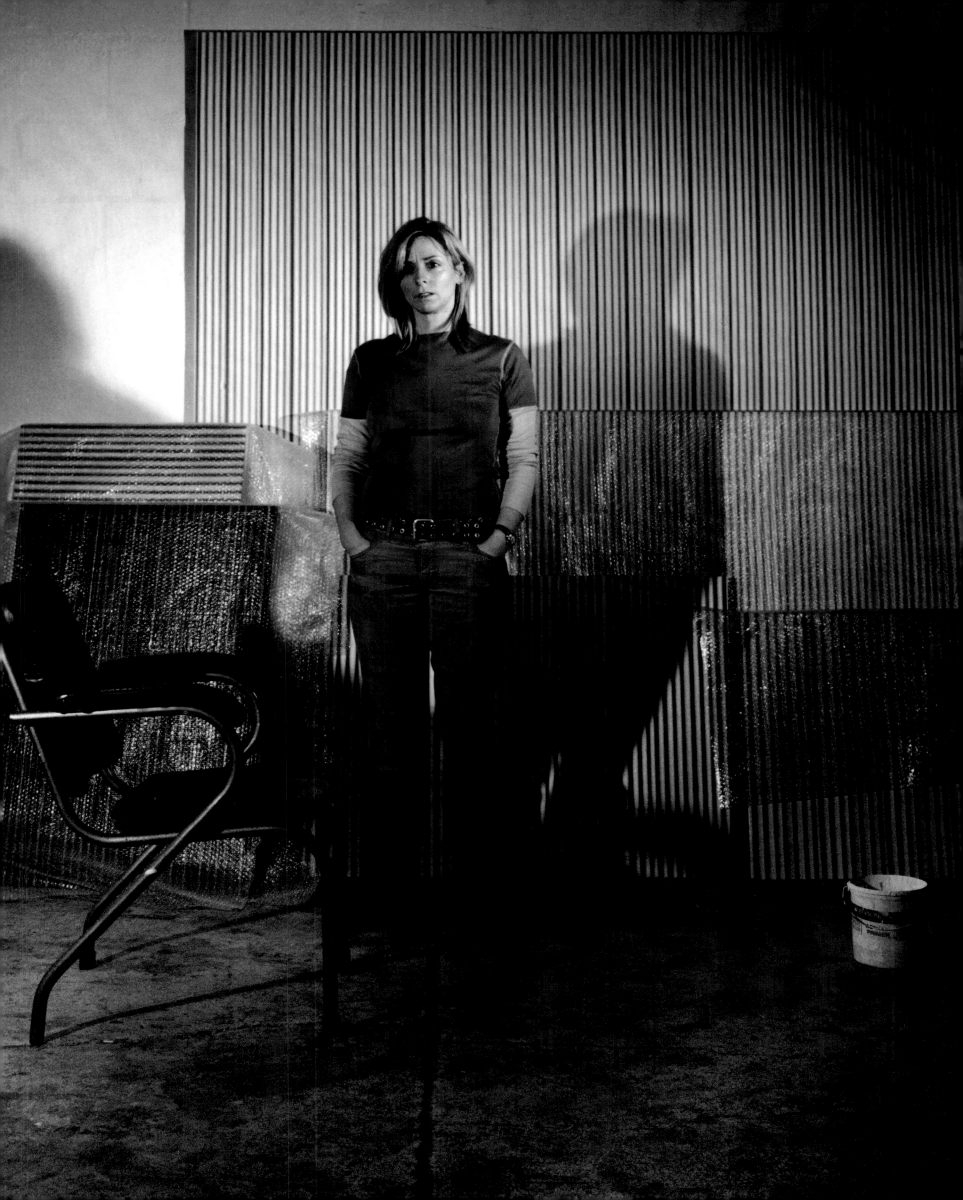

First published 2001 by Merrell Publishers Limited

'Nimbus' © 2001 Tony Godfrey
'Being Here: New Paintings by Estelle Thompson' © 2001 Deborah Robinson
Illustrations © 2001 Estelle Thompson, with the following exceptions:
p. 11 © The National Gallery, London
p. 16 © 1958 Morris Louis; photograph reproduced by kind permission of
the Trustees of the Museums and Galleries of Northern Ireland
p. 5 © Dennis de Caires
p. 118 © Aubrey Bowling

Produced by
Merrell Publishers Limited
42 Southwark Street
London SE1 1UN
www.merrellpublishers.com

Distributed in the USA and Canada by Rizzoli International Publications, Inc.
through St Martin's Press, 175 Fifth Avenue, New York, New York 10010

British Library Cataloguing-in-Publication Data:
Estelle Thompson
1.Thompson, Estelle – Criticism and interpretation
2.Painting – Great Britain 3.Light in art
I.Title
759.2
ISBN 1 85894 152 0

Edited by Julian Honer
Designed by Maggi Smith
Photographs by Matthew Hollow, Hugh Kelly,
Anthony Makinson at Prudence Cuming, and Miki Slingsby

Printed and bound in Italy

ACKNOWLEDGEMENTS

Estelle Thompson and the directors of Merrell Publishers and
the Purdy Hicks Gallery, London, would like to thank Peter
Jenkinson, Deborah Robinson and all the staff at The New Art
Gallery Walsall for making this book possible.

The artist would also like to thank Hugh Merrell, Julian Honer,
Maggi Smith, Matt Hervey, Tony Godfrey, Dennis de Caires,
Pete Kosowitz, Adam Withington, Kevin Rice and Odile de
Caires; and Rebecca Hicks, Nicola Shane, Frankie Rossi,
Sabrina MacKenzie and Jacqui Saunders at the Purdy Hicks
Gallery.

Estelle Thompson's work is represented exclusively by
Purdy Hicks Gallery
65 Hopton Street
Bankside
London SE1 9GZ
www.purdyhicks.com

CONTENTS

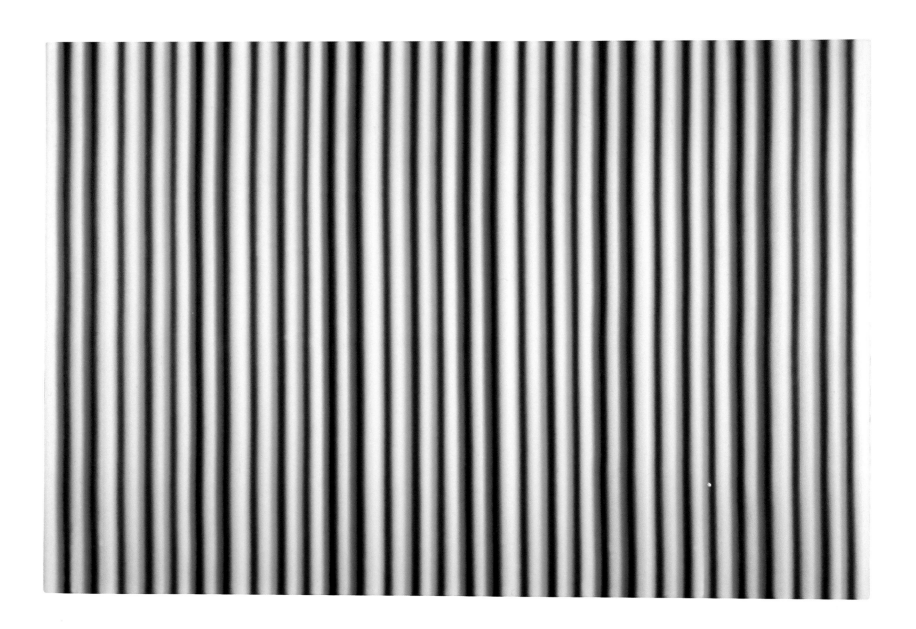

<=>
2000
Oil on panel
70 x 100 cm

NIMBUS

Recently, at the private view of an exhibition, hundreds of people were milling around, champagne glasses in hand, voices raised to be heard above the hubbub. "I never thought", a painter remarked to me as she, quite literally, bumped against me, "that I would see Estelle Thompson do process paintings." She pointed at <=>,[1] a painting of five coloured bars – pink-black, red-black, yellow-black, blue-black, green-red[2] – each repeated six times. "Actually, she hasn't become a process painter ...", I said, but before I could explain myself the crowd swirled and eddied around us and we were swept away in opposite directions. What I had wanted to say was that, whereas a process painter was a willing slave to a set of pre-determined instructions or a formula of geometry, Estelle Thompson *used* geometry, that her works were still modulated by touch, by fingertip sensitivity. I wanted to say that, although this painting seemed chromatically brilliant – a clarion-call in the tumult – cold and calculated, it was in reality warm and intimate; that if she could view it for a while, unhurriedly and in peace – a state of mind not easily obtained that evening – she would discover it was not a Wham! Bang! piece of Neo-Geo, or Op Art revisited, shouting for attention; that it was wholly misunderstood if it was assumed to be a simple, strong statement as rapidly understood as a logo, but that, in fact, it was a slow painting that was distinguished by the subtlety and variation of pulse, by the evocation of a very particular light sensation – that it had a "nimbus".[3]

Nevertheless, I could understand how she had made such a sweeping judgement in passing. Estelle Thompson had made her reputation in the mid- to late 1980s with lyrical, romantic paintings that evoked landscape sensations and that were distinguished by a highly sensitive handling of paint.

For example, since 1987 I have lived with one of her paintings, *Rive*, a 5 x 5 ft canvas. My initial enthusiasm for the painting had a great deal to do with the way it seemed to synthesize landscape sensations – not from direct observation of nature, but implicitly or indirectly: a grey-blue margin creates an arch or oculus within which, against a faded duck-egg blue, two rock shapes, rounded below, jagged above like teeth, are poised. Between these two 'teeth-rocks' the blue is a dark ultra-marine. From the top edge of the painting a white shape like a tongue, finger or cloud extrudes, reaching down nearly to touch the shapes and the ultramarine pool. Behind, as though distant and hovering, are two much smaller 'rocks'; a pile of shapes, tinged with brown – perhaps bone-sticks rather than rock-teeth – is painted rather uncertainly in the lower right-hand corner. After a while, however, one stopped trying to see it as a landscape *per se*. One became more conscious of the way it was painted: the way paint had been flowed down through the left rock-tooth, leaving a grainy residue like sedimentation from a flood; how the brushstrokes worried at the near-fraying edges of the shapes. One became aware more of how shapes are in conversation with one another, poised one against the other like dancers: tooth-rock against tooth-rock, pool against finger. It is atmospheric not descriptive: water, mists, things in motion, melting. It is an exercise in the washing,

1 In 1999 Thompson invited Andrew Toovey, a contemporary composer, to title her paintings using his knowledge of musical notation. She has recently been using signs, symbols, punctuation or computer terms as titles. She has done this because she finds titles generally too obstructive or too "instructive". She wants you to see the painting, not to look at what you are told it is. One recalls Paul Valéry's dictum, "Seeing is when you forget the name of what you are looking at".

2 Of course, colours are never this simple in Estelle Thompson's work: they are always very particular tones, to maintain the consistency of which she mixes the colours in quantity before working, originally keeping the paint-soaked rollers as a reference.

3 It is worth noting here that Thompson herself, in notes for a lecture pasted into a notebook refutes the suggestion likewise:
"These are not process paintings, forget how they were made, it is part of their being but not of their significance
Composition comes out of their making, how they are made? ; edge to edge. What do they evoke? A continuum, a singular spatial consideration
The significance of detail, microscopic pointillism, a shift in scale, large line, little dot
Surface and material; selection, they are warm and organic
Order, control, imperfection, irregularity, symmetrical asymmetry, deliberately flawed, repetitive but never the same
Human presence
Colour relationships. Poetry of developing language, surprises along the way, no theory, no system, indulgent sweet shop, mixing and tubing the pigment, lying out lines like possible instruments ..."
Grid notebook, unpaginated.

flowing, intensifying, blurring, sharpening, fraying and abrading of paint – colour in liquid. As a painting it is unusually sensitive to where it is hung: when we moved to a flat with a high white wall that we thought would suit it perfectly it was unbearably cold, like a block of ice sliding down the wall. Moved to another wall with a lower ceiling and less direct light it grew reflective, calm but not cold: it spread out on the wall, that is to say its colours and light seemed to affect the area around it, whereas before it had seemed tightly enclosed within itself. Now in a Victorian building with a lot of dark wood and relatively subdued light, it seems calm but never chilly; indeed, it radiates. Robert Ryman, producer of white canvases whose tonalities are subtly modulated, has written of how the space his paintings occupy extends out a foot to a foot and a half beyond itself; so it is with this painting – it responds to and activates the wall.

Other than this, its sensitivity to space and its ability to create a particular space, and its ability to evoke landscape sensations, the painting is distinguished by three things: its ability to slow time down: it seems in flow but is unchanging; its limpidity: light refracts through it as through a glass of cold, clear water; and its tension: like a meniscus or a drum-skin freshly tuned, the surface of the painting is highly sensitized.

How, then, do we compare this to the paintings of fourteen years later, and how did we – or she – get there? Was there a slow development or a sudden change of style and intention? Obviously, this essay seeks to elucidate these questions, but for now we should note the differences between *Rive* and <=>: where one immediately summons nature as its touchstone, the other seems to summon geometry; where *Rive* uses closely toned colours, <=> uses contrasting colours. <=> is a better painting than *Rive*: it has a coherent composition, whereas *Rive* has areas that are, ultimately, unresolved. Both evoke depth, if not in a perspectival sense; both play on silence and yet seem to evoke music; both show exquisite craftsmanship and sensitivity to paint, but with apparently very different tools. However, the nature of the background is perhaps where we find the closest similarity: as indicated above, the tension of the surface, a tension closely linked to the tension between the shapes has remained consistent.

What development led to *Rive*? Thompson's work of the late 1980s – in its adherence to the machinery of romantic landscape: mists, harmonious colours, lyricism – may seem to express a longing for union with landscape, yet she has never, save for a year in Normandy, lived in the countryside. But she has travelled a lot and the experience of different lights and colours has been crucial.[4] Looked at retrospectively, the landscape forms were, first and foremost, vehicles for light and colour. In subsequent paintings of the 1990s (as we shall see), plaids, grids and rows of bars act, arguably, as equivalent urban containers for light. She grew up and went to school in the urban environment (the West Midlands); her father was a draughtsman specializing in silos and industrial equipment. She remembers his detailed technical drawings and seeing in a factory huge aluminium silos and containers.

Thompson moved to Sheffield to take a degree. Paradoxically, although she was enrolled specifically on the painting degree course – a rarity at that time when many courses were switching to an all-inclusive fine art course – she was as interested in photography and film. However, although she was interested in a broader, more conceptually based practice, she chose to paint. These paintings reflect both her investigation of materials and mixed media and her interest in

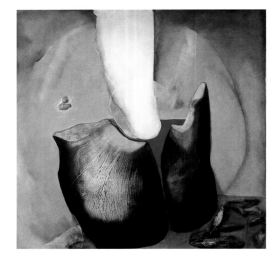

Rive
1986
Oil on linen
152.5 x 152.5 cm
Collection Tony Godfrey

4 Thompson refers, *inter alia*, to the Atlas Mountains of Morocco; the Himalayas and Jaipur, the pink city in India; the Colorado desert; the South American rainforests; Venice; New York; and the Yorkshire Moors. When she had a studio in Docklands, she was always aware of the light from the Thames coming through frosted panes.

5 Robert Rosenblum's *Modern Painting and the Northern Romantic Tradition: Friedrich to Rothko*, London (Thames and Hudson) 1975, was being widely read at this time.

6 Margaret Atwood puts this very clearly: "Nature poetry is seldom just about Nature; it is usually about the poet's *attitude* towards the external natural universe. That is, landscapes in poems are often interior landscapes; they are maps of a state of mind." *Survival*, Toronto 1972, p. 49.

7 Evidence of this lies most clearly in the notebooks that Thompson has kept since leaving the RCA, in which thoughts and observations are mixed with quotations from books she has been reading and that she wants to meditate over further. This is as much the fuel for her paintings as an ongoing reflection on the history of painting, the experience of working with materials and being in and looking at the human, physical world. A typical notebook (undated) contains, *inter alia*, extracts from Meyer Shapiro, Spinoza, Wittgenstein, Peter Høeg's *Miss*

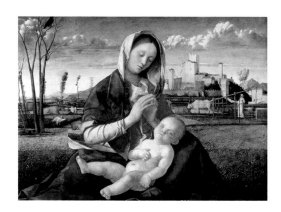

Giovanni Bellini
Madonna of the Meadow
Oil and egg tempera on wood
67.3 x 86.4 cm
The National Gallery, London

Smilla's Feeling for Snow, Barnett Newman on the sublime, Louise Bourgeois, the photographer Hiroshi Sugimoto, Kafka, the Mexican architect Luis Barragan and Frank Stella (yellow notebook). There are several of these notebooks extant. It is impossible to date them precisely as she has filled them in an unsystematic way. The majority of things written down in the notebooks are quotations from her reading, or sometimes paraphrases of it. On occasion, her own observations mingle with these quotations and paraphrases but it is difficult to determine which is which. Thompson remarks, "The 'scatterlogical' nature of notebooks is the result of practical use, and reflects how we experience the world, particularly the modern, technologically bombarding one. I acquire knowledge and come into contact with things – there is a random nature to that occasionally mind-blowing coincidence."

8 Note to author, 2001.

9 "Looking at painting. Its significance for me. There is no substitute. Looking at painting requires the whole body and focus in front of work. The sophistication of our sensory mechanism, viewing generally (ie advertisements, film, TV). How much information we take in whilst viewing something. Its size, format, image, colours, surface, mood, message, title, context." Note to author, 2001.

current gender and sexual politics. Her undergraduate thesis was on feminist art: Nancy Spero, Judy Chicago, Alice Neel *et al*. If such ideas are no longer explicitly in the work, there is, nevertheless, a stance and determination to her position as an artist that owes something to them.

When Thompson went up to the Royal College of Art (RCA) in London, she was making paintings with single upright figures. In the last of these the figure was lying along the bottom edge. And then, she has said, it was as if that figure slipped off, leaving only the landscape background. What had transpired to be important was the making rather than the explicit subject-matter. This was a time (1983–86) when there was a good deal of discussion about whether landscape could be the basis for painting that would be at once forward-looking and linked to tradition: such artists as Anselm Kiefer and Enzo Cucchi, who used landscape as a vehicle for examining both communal cultural experiences and the situation of the individual, were being internationally shown. It was a time when artists were looking again at St Ives, at Abstract Expressionism and the English landscape tradition.[5] There was much talk about the sublime at this time, a revived interest in Turner, Caspar David Friedrich and the Hudson River School; however, Thompson's paintings were never about the sublime, but rather about being here. Landscape for her was always about creating a space in which to look at oneself, not about being in the landscape *per se*. One could describe what she was painting either as poetic landscapes,[6] or say that these imagined landscapes were, in T.S. Eliot's terms, objective correlatives for her feelings.

Thompson went to the RCA at the last time when students of painting there were being told to situate themselves in a European tradition, that painting was an ethical activity. This was a moral approach to beginning a career as a painter rather than a commercial one. In retrospect, Thompson realizes that she learnt more from the critical stance of such people as Peter de Francia, John Golding, Ken Kiff and Mario Dubsky than their actual work. (Paradoxically, she was being taught by a group of primarily figure painters at just the moment when the figure had slid out of her own work.) Crucially, she found the course intellectually rigorous: her propensity for reading developed; her inclination to match theoretical speculations to the activity of painting began.[7]

"People seem to find it hard to look at a painting; painting is on the edge of our daily visual experience and consequently they want to use everyday eyes. It takes time to really look at something and longer to understand looking, we don't necessarily need education to do it but time."[8] For Thompson, as for so many other painters, the National Gallery in London was where she learnt to understand looking.[9] She became fascinated by Bellini and Quattrocento altarpieces. How does one relate *Rive* or <=> to Giovanni Bellini's *Madonna of the Meadow*, for example, a painting that has remained a touchstone for her? Bellini's painting shows the Christ Child asleep on the Virgin's lap – a posture often interpreted as a prefiguration of the Lamentation after his Crucifixion. It is perfectly still with not a breath of wind, a peasant lies behind in deepest sleep, and yet there are tremors of unease: behind the Virgin's right elbow a snake rears up at a stork, while on top of the tree a giant raven is poised, like a bad omen. The Virgin is protective, calm, her lap, cupped hands and, by visual association, her hood encircle and protect the child, yet her expression can be read as one of reflectiveness and foreboding. All this is echoed in the painting in a formal, visual manner: the dark blue against the light blue: the static pyramid of mother and child against the extraordinary way drapery is painted razor-sharp on her hood and especially in the cloak by her right elbow. The Christ Child floats in a sea of blue; nobody touches him. The trees and all the other vertical elements set a

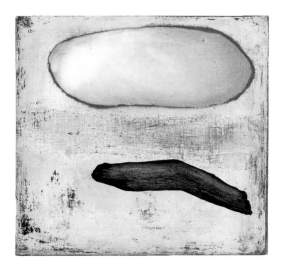

(left) *Littoral I*
1988–89
Oil on linen
30.5 x 30.5 cm
Private collection

(right) *Littoral II*
1988–89
Oil on linen
30.5 x 30.5 cm
Private collection

rhythm though the painting from left to right. It is like the surface of a pond, profoundly still, as unmoved as a mirror, just before something rises to the surface, rupturing this seeming membrane. It is one of those paintings whose beauty is able to surprise, even shock, one periodically.

I would argue that although *Rive* seems closer to the Bellini in its landscape elements, its use of blue and in its variations of sharp and general painting, it is <=> that is in fact closer, for it has an equivalent pulsation of colour and rhythm to those that underpin the Bellini. Most importantly, it attains more successfully to that state of the painting surface as a membrane, a tense, sensitive film.

Painting, as Thompson sometimes remarks, deals with unconcrete, unnameable things as if they were concrete: crystalline freshness, a mood of something about to happen, its immanence already running through like a pulse. As always, it is the background, stretched tight as a newly tuned drum, that carries the expectancy.

Crepuscular. Gloaming. Plangent. Words that describe that stillness as night turns into day or day into night: moments when light hangs heavy, when colours seem malleable, when nature seems to echo those liminal states between sleep and consciousness. Thompson wants the light inside the painting to hover outside it, too, as in the Bellini. "The light of the painting radiates out towards us." [10]

It was in a series of small paintings that Thompson began to work out the problems that these large landscape-orientated paintings of the late 1980s had set her. The whole notion of poetic landscape in the 1980s faced problems, especially in finding compositions that were not self-conscious or formally unconvincing. How to make such metaphoric statements without sounding arch, nostalgic or inauthentic? Cucchi and Kiefer had been able to avoid such problems by the use of self-myth and historical reference. The format Thompson elected to use in this extended series of small paintings that began in 1986 was a 12-inch.[11] The smallness of the paintings and their squareness (12 x 12 in.) militated against an automatic landscape reading and emphasized instead their thingness, their objecthood. This thingness was often emphasized by the way the paint surface was rubbed around the outside edge. They were as much paintings as objects in this world as paintings purporting to be windows or gateways through which one saw representations of things in this world. Whereas the large paintings had referred, however indirectly, to the grand tradition of epic history painting or of Abstract Expressionism, these smaller works were closer to icons, where the intensity seemed almost other-worldly. They were always cogent and satisfying.

10 It is worth noting that at this time she was, as one would expect from someone interested in the Northern Romantic Tradition, interested in Caspar David Friedrich. "I think the light very different. Rather than making light, Friedrich gives evocation of light, through inventing/capturing dramatic light situations. We are always asked to walk (mentally) in to a Friedrich painting and watch at a distance the hot red rising/setting sun. Bellini is light become tangible. The light of the painting radiates out towards us." Notes to author, 2001. In a subsequent note she writes of the Bellini painting of St Francis in the Frick Collection, New York – another touchstone: "I like the notion of momentarily when a painting really hits us. We might catch ourselves holding our breath, or at least being aware of our breathing and being. Being with a painting – standing in front of it – is such a *human* activity. Two human beings locked together momentarily, trying to make sense of being here."

11 Thompson may have made several hundred between 1986 and 1997. After 1995 she began working with the larger format of 14 x 14 in. In a way these acted as a substitute for drawing.

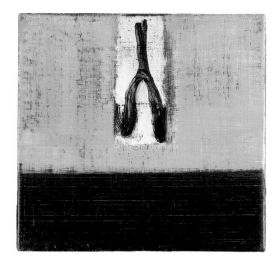 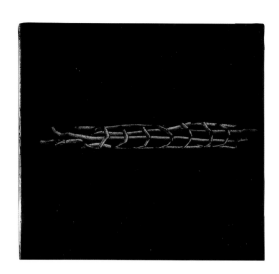

Squareness is in art associated with the analytic or austere: scientific photographs, the unnerving photographs by Diane Arbus of alienated people, or the black-on-black paintings of Ad Reinhardt. Sometimes, as with Kasimir Malevich, it also has the association of the religious icon: see the photographs of his studio, where paintings act as solace – fragments he has shored against his ruin.

Small paintings traditionally allow a quick response to observations and thoughts, allow an exploration of materials (as in the work of John Constable) and expedite the discovery of new motifs (as in the work of Philip Guston).

What do we find? Simple shape, textures and often elements that simultaneously had connotations of body and nature. The construction of a visual grammar. But the placement and making is always precise and sophisticated. It was as if she were creating a dictionary of 'meaning shapes'[12] that she could put through different contexts and climates.

In two early small paintings of 1988–89, *Littoral I* and *Littoral II*, two elements from *Rive* reappear: the pool and the stick-bone. But there is no undue complexity here: the gaze is far more analytic; the objects hang, paradoxically, with a greater presence and poignancy.

In two other small paintings, *Faith* and *Wooden Glass*, simple, single shapes float as if isolated by the microscope. Or perhaps it would be better to say that they are virtual shapes that float in a virtual space, save that the surface they spin against is so physical that every trace of its facture is clearly visible. They are far, far more sensual than the virtual. The objects and the space they float in seem to have a history. The forms are difficult to pin down: a wishbone? a branch? or just a brushstroke?

This is in line with the emphasis on simple things in the world that we find in the work of many artists and writers of the twentieth century: William Carlos Williams; the Imagist poems of Ezra Pound; the oft-repeated chord of La Monte Young; the paintings of Giorgio Morandi in retreat in Italy, fixated on a bottle or pot; Philip Guston at the end of the 1960s, looking for a simple thing he could believe in, such as a mug, a nail or a line. The ambiguity of the objects, or their association, was something that Thompson deliberately sought.

Parallel to this was an interest in language: extracts of poetry litter the notebooks that Thompson began to keep at this time, along with lists of words. In effect, she mirrors the act of archaeology of visual shapes in the small paintings by archaeologizing words, often obscure and archaic:

12 The term 'meaning shapes' could, of course, be related to the term 'thinking objects' that Tony Cragg used of his sculptures at this time. By using 'meaning' rather than meaningful, I seek to suggest that the shapes lead to ideas and emotions rather than carry them as a noun might hold an explicit meaning.

Furrow	Enclosure	Land
sulcus?	corral	isthmus
slit	kraal	alluvium
sulcated	fosse	alluvion
trisulcate	quick-set hedge	world
		glebe
		marl
		littoral
		riparian (riverbank)
		ripuarian
		rip-rap[13]

13 Brown notebook, unpaginated. In the same notebook, dictionary definitions are appended to titles from Morris Louis's paintings, for example, "*Approach. 1961.* to bring near; to come near to in any sense; to come into personal reflection or seen communication with; to resemble – v.i. to come near. – n. a drawing near." We also find lists of possible titles for her own works in this notebook.

14 I use the terms as Nietschze did.

This interest in language was not so new: 'rive', a word one may have assumed to be connected with the French '*rêve*' (dream), in fact was an archaic word (although the passive 'riven' still occurs) for split or tear apart violently. There was a clear destructive, or Dionysian, strain in Thompson's work throughout this period. Contrariwise, abstract painting is normally Apollonian or constructive. Indeed, it may be worth thinking of her recent work as more Dionysian than Apollonian: it tends to ecstasy rather than calm, to disorder rather than order; however subliminal, there is always the potential for transgression in her work.[14] The membrane of the paintings is sensitive, and in some small paintings, such as *Locate* and *Tear*, the rupture of this surface is crucial. Not untypically, the title is a pun: a drop of water from the eye denoting sadness, or a rip in the fabric. In that pun lies the tension in her work: between the object, the surface and its rupture. Slits, gashes and gaps recur in her work. These are the counterpart to beautiful harmonious surfaces. The surface itself can be read as skin, the surface of the body, these slits or tears as apertures or wounds. Formally, these cuts penetrate the picture plane: they nail it to the wall, much as did the nails that Francis Bacon frequently painted on to his own canvases.

In other small paintings by Thompson, the organization of the surface into quasi-grids or -patterns was more key: whereas *View* could be seen as a rethink of landscape formats and the sense of depth, *Twist* is not untypical of a tendency to use the grid or set of bands to blur, fix or wound the

(left) *Locate*
1990
Oil on linen
30.5 x 30.5 cm
Private collection

(centre) *Tear*
1993
Oil on linen
30.5 x 30.5 cm
Private collection

(right) *Every Twist*
1991
Oil on linen
30.5 x 30.5 cm
Private collection

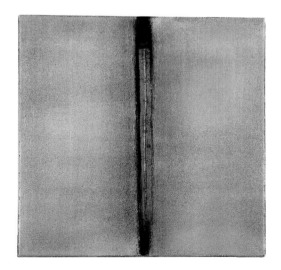
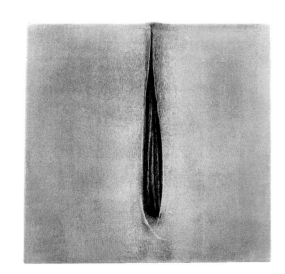
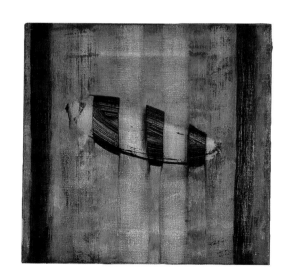

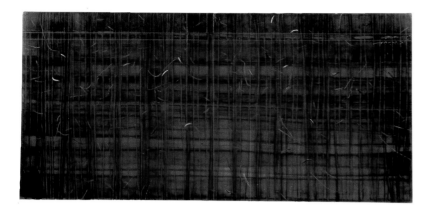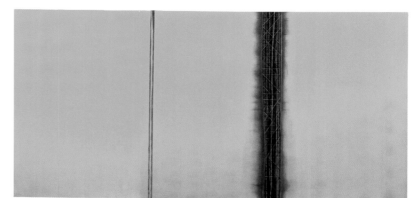

(left) *Scatter*
1993
Oil on linen
152 x 304 cm
Collection Mr and Mrs Richard
Morse

(right) *Close up Closer*
1993
Oil on linen
152 x 304 cm
Collection Mr and Mrs Andrew
Dalton

15 Thompson writes that the use of the roller is not "for technical know-how – but significance to final painting – tension – tightrope walking – the nature of precision returning to a line, maintaining steady precise build up, layer on layer, – controlling the roller, reaching up and slowly leaving paint over the surface. Pulling downwards – one continuous movement to bending of the knees and exiting bottom of the surface, release of tension. Holding one's *breath*."

16 "NB Use of the fused colour + tone + hue + application (resulting in surface density etc.) is for me the means to force the illusionistic space from the symmetrical/all-over configuration." Yellow notebook.

17 Ironically, when a painting of Newman's in the Stedelijk Museum, Amsterdam, was vandalized it was for the use of a roller that the restorer was subsequently sued.

18 See Judy Chicago's famous book *Through a Flower*. The centralized imagery normally transpired to be a vagina.

19 See the suggestion by Naifeh in his biography of Jackson Pollock that his all-over drip paintings were connected to his propensity to displaying his penis and urinating in public.

motif. The grid or set of bars becomes as much a rupturing device as a securing one.

In retrospect, what was crucial (to continue the metaphor of a grammar) in this sequence of small paintings was not so much the discovery and refinement of a dictionary of shapes as the syntax that linked them: the relationships between forms and colours. The intervals between the shapes, the way they communicated across and through the surface, was key.

By 1992 Thompson's large-scale painting had changed dramatically in response to the discoveries in the small paintings. Now the paintings were very large – 5 x 10 ft – and the space they created was very different. The double square was not a landscape format, and the loose grid that such a painting as *Scatter* uses also confounds such readings. Little flickers of electric yellow skip around the grid or plaid, which, importantly, has been applied by roller. The use of a roller to apply paint (a technique Thompson began using in 1993) leads to a smoother, more all-over surface, but it is not a refusal of the human touch in favour of a machine aesthetic – merely a different way of applying paint.[15] Although the roller attracted her as a tool because she wanted an overall evenness to the big paintings, it was the speckling that they produced that fascinated her, a speckling that acts, as she puts it, like "microscopic pointillism". The space in *Scatter* has the same potential depth as the landscape works, but the structure is consistent and coherent.[16]

Close up Closer confronts and *detournes* the sublime abstract field paintings of Barnett Newman with their 'zips', such as *Vir Heroicus Sublimis*. The 'zips' are neither sublime gestures reaching to the heavens, nor stick-like Giacometti figures. Indeed, "zips" – Newman's own term – is wrong; bars would be better. The bars carry a wide range of natural associations; imagery is not abjured here. Rather, one should see them as ruptures in the skin of the painting. Paradoxically, although Newman, notoriously, used a small brush and Thompson uses a roller, the hand-worked sensitivity is truly crucial to Thompson.[17] The positive becomes a negative, the bar a slit or tear, a gap into space, an aperture through the body. Figure–ground relationships are inverted.

One should not exaggerate the way in which, as in the small paintings, for example, centralized imagery recurs, in accordance with the early feminist ideas of Judy Chicago.[18] However, the way in which a specifically female consciousness may be understood as being in, or speaking through, these paintings is far less readily deciphered than early feminist thought would wish. It may be found in an 'all-overness' that is not imbued with notions of the sublime, the heroic or the highly signatured.[19] What we have here is a rapprochement with classic American abstract painting, but in terms of skin, the body and psychic space. This is not unique: the American painter Sue Williams,

whose earlier paintings were angry graffiti-like attacks on male aggression, has recently shifted to a way of painting that is clearly intended as a feminine, erotic version of all-over drip or gesture painting, with a surface that has recurrent suggestions of skin, whether smooth, folded or creased, where surface tension is recurrently broken and repaired.

Thompson's emphasis on the surface has never been just a formal matter, nor to the detriment of other elements: "You can say surface is everything, space is key, colour and light are what painting is about, but ultimately its only any good when all of these act as one."[20] All you see in a painting is the surface, but everything else is there.

It is inevitable that art historians will think of the work of Morris Louis in the context of a discussion of Thompson's work, for it was he who was the first to commit himself to painting stripes as a format. Perhaps to some people's surprise, however, given Thompson's most recent paintings, she prefers Louis's *Veils* to his *Stripes*, liking, in particular, the complex integrity of the best veil paintings: the way a logical process (pouring washes of acrylic paint over unprimed canvas) gives rise to such a rich and unexpected result, the way each painting develops a very particular and individual mood.[21] Louis's *Unfurleds* – paintings in which strips of paint were poured diagonally across each side of the canvas, leaving the centre empty and sensitive – also intrigue her: the way in which those few strips could create tension across the entire expanse of the canvas.

A work such as Louis's *Golden Age* is not untypical of how, in the late *Veils*, a series of simple, flowed colours – identifiable as though in an index at the top – are combined into one vast chordlike statement. It is worth noting that the progression from Thompson's abstracts of 1993 to her *Punctuation* works of 2000–01 is far more gradual and coherent than that of Louis from the *Veils* to *Stripes*. Louis was never a process painter, but ended up doing process paintings: with seeming paradox it was in such works that his sensibility was able to reveal itself. The more tightly interlocked his paintings were, the more passionate and heightened they became. The literature on Louis is strangely unsatisfactory: classically he was the protégé of Clement Greenberg, and Greenbergian formalism has dominated the discussion ever since, but its quasi-philosophical discourse has always failed to explain or even describe the extraordinary beauty of his works. More recently, even such an accomplished writer as Arthur C. Danto (a real philosopher rather than a quasi one) has fallen back on the profoundly inadequate metaphor of saying that looking at the *Veils* reminds him of walking through negligees in a department store.

Thompson's *Bar* and *Punctuation* paintings of 1997 onwards develop out of the paintings of 1993–96, which she sometimes refers to as the *Fuse* paintings. They take their format and process from a painting such as *Fuse* itself, but are far more focused. These works are difficult to write about or explain adequately; or, to put the problem more precisely, to say how they are made does not explain what the experience we have in looking at them is. How to describe these paintings, or rather their effect on us? There is a sense of grace, at odds, or so it seems initially, with the shimmer and vibrancy of the colours. They have a visceral effect on us: we are pushed away by the vibrancy, yet seduced – pulled in – by the colours' succulence, caught by the repeating pulse, confounded by the way we cannot see the whole painting at one go. We keep getting immersed in them. They have a psychological effect. Strange things can happen with the identity of the viewer.

Nevertheless, as learning how these paintings are made is crucial and revealing, not just for her, but for ourselves as viewers, it is wholly appropriate and natural to ask the question, "How did she

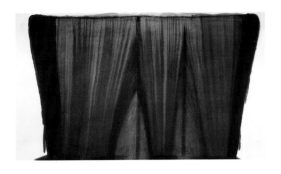

Morris Louis (1912–1962)
Golden Age
1958
Acrylic on canvas
231.1 x 378.5 cm
Ulster Museum, Belfast

20 Note to author, 2001.
21 Louis spent the last eighteen months of his short career making nothing but striped paintings. Thompson has also become interested in the work of Gene Davis, another painter of stripes from Washington, DC, whose work has been seen relatively little since his death. Whereas Louis's stripe paintings are generally small (five to eight stripes), Davis covered large canvases and once even painted a whole street in Washington with stripes.
22 Note to author, 2001.
23 Thompson insists on these two words.

16

do it?" Moreover, part of the experiencing of a painting is to imagine oneself as the painter, retracing his or her steps.

Mixing colours is key for Thompson: before she begins painting she mixes the paint and retubes it. "I love analysing colour, unlocking its components, unmixing it before mixing it."[22] She does this from a need to keep the colour consistent throughout the painting so that there is no impurity or variation in the finished product. She approaches the painting with as much clarity as possible. Music may be playing in the studio, but there is no unnecessary clutter, no mess of postcards and jottings on the wall as in most other artists' studios. Having worked out the exact format of the painting and the number of bars it will take, Thompson loads the roller with between four and nine colours and rolls it on to the panel or metal. (She has discovered that seven is the optimum number of bars: it is what fits the eye and the roller. Paintings with nine bars exist, but they get crowded.) This is not merely mechanical: fingertip touch and sensitivity are necessary, constant attention to maintaining the tension and tenderness of the surface, constantly bearing in mind the painting as a whole. The bars will have to be rolled several times, adjusting one set against another. This touch, however refined, however seemingly slight or nearly invisible, is always key: it is not a machine distribution. (An equivalent might be the near-monochrome works of Brice Marden, in which the slight variations and 'mistakes' are so essential.) The imperfections in the *Bar* and *Punctuation* paintings, however miniscule they may be, are always crucial: they are what make the paintings breath.

When Thompson is working, her main concern is with maintaining a "dynamic equilibrium". She talks about pulling the other colours up, or of activating the colours. Her concerns are very specifically formal. The roller has become crucial to her: spraying would not work because that would not have the human touch on which she insists; the colours would not *bleed*, nor would they *blend* one with another.[23]

Thompson's small paintings gradually ceased to be so important, and by 1995 she began to do fewer of them, while also making them somewhat larger (14 x 14 in.). She was starting to find them too limiting; indeed, they seemed to trap the rhythmic build-up she sought. The smaller works she makes now are more clearly studies – preparations for the large paintings. The square format (or double-square format for large paintings) had become a straitjacket for her: it was difficult to activate, so she began to use a

Red Fuse
1995–96
Oil on linen
152.4 x 304.8
Private collection

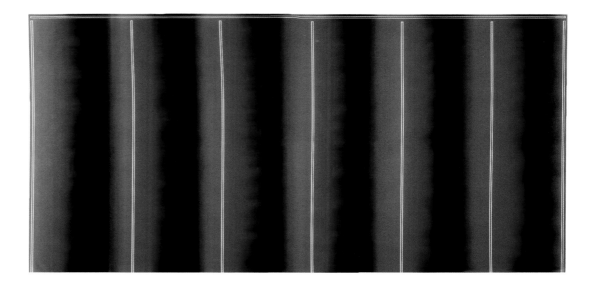

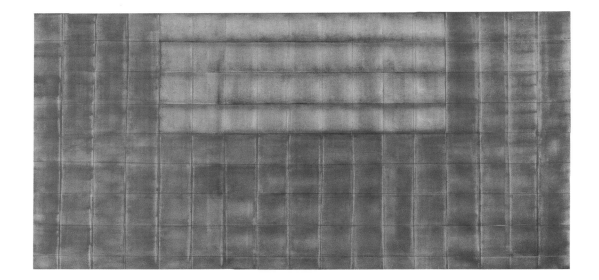

Gentle Burning
1993
Oil on linen
152 x 304 cm
Collection Dresdner Kleinwort Wasserstein

variety of predetermined rectangular formats.[24] Essentially, Thompson herself needs these formats for herself as keys to respond to, much as a composer must elect a key before improvising.

Why should one call the vertical elements in Thompson's work bars and not stripes? Because they are about stopping entry and exit, and about recession, and about rounded form, and are not decorative; in other words, they are not just about optical effect and 'scientist' play. Also, because the word stripes suggests the discourse that has revolved around the work of Bridget Riley, and which is not as relevant to Thompson's work as may be imagined. It is the differences that matter here, not the similarities.[25]

Just as Thompson's paintings of the late 1980s were a response to the attempt by many at that time to make a rapprochement with romanticism and figurative imagery *via* a way of painting that was more gestural or derived from abstraction, so her paintings of the late 1990s can be seen as a significant contribution to the more recently prevalent discourse about the ideology of abstraction underpinned by speculation as to its possible spiritual or psychic content. How, then, do we identify content in the bar paintings?

Comparing abstract art to music has a long history, going back certainly to Kandinsky, and beyond that to Whistler. One must use the comparison with care, however. Nevertheless, I am always reminded here of Terry Riley's *In C* (1964), in which, against an endlessly repeated pulse, a set of musicians play fifty-four fragments of melody, each in the same sequence, but each as many times as they feel appropriate: the score was so short as to be published on the sleeve of the original LP, but the effects are extraordinarily various. For many, hearing its recent performance at the Barbican Centre, London, was a unique experience: the effect was similar to Thompson's paintings in that one oscillated between detail and the whole, one lost sense of time, one became immersed.

There is no repetition in music.

Compared with the Bellini painting we discussed earlier, this is a very precise and sophisticated tonal statement, like a chord that resonates in the room as one watches it. What would I mean if I were to call each painting chordal? That each painting is like a fugue that, enumerating each note one by one, in order clearly to indicate their relationships, repeats and repeats until all notes, all relationships, are held in one exuberant, resonating chord. Thompson's works have always been about

24 Recently Thompson has begun to use formats from Christine Heider, *Dynamic Symmetry: A Primer*, New York 1966. There is a mad quaintness to this book – a strangely homespun feel, as though the writer had, like a late-developing child, just discovered mathematics and been dazzled by its symmetries and unexpected assonances.

25 This is not to say that Thompson does not have enormous respect for Riley.

White Lie
1993
Oil on linen
152 x 304 cm
Collection Robert and Vanessa
Devereux

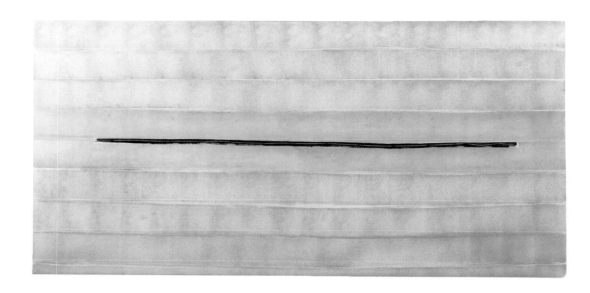

26 Yellow notebook. In another section of the
 same notebook, again typewritten and pasted
 in, Thompson expands on this statement:
 "IN THE STUDIO
 Realization of what inhabits my studio
 Clear, clean, white space, conforms to
 contemporary norm. Mondrian's monthly
 paint-out. Highly ordered, filed, efficient.
 Practical considerations as well as clarity
 of thought.
 Large slit window on the world.
 Over shoulder, high, a view of the Westway
 flyover and sky above.
 Nothing to focus or to concentrate on other
 than the changing light and weather.
 Only current canvases.
 No photographs, clippings, notes, sketches,
 postcards, reproductions.
 Kitaj: books; Patterson: box; Hume: kitsch
 clutter; Guston: wife's poems.
 Me: just music.
 Earlier radio always voices conversations
 floating in and out, a human presence.
 Loud music, volume and volume and space.
 Opera singer, Lynchberg, Virginia: different
 to band venues and jazz clubs where sound
 bounces off architecture; here sound had
 sculptural form and notes made shapes and
 trails it was possible to follow
 Music becomes physical companion in space,
 rhythms are record of others activity, like a
 heartbeat or presence.
 Indian classical ragas, opera, ambient music,
 'trance', choral, chants.
 Music is not the subject of these paintings.
 Barnett Newman and abstract painter versus
 the new painter.
 Old space, new space, visteral, frontal, dense,
 restrictive, woven, fused, built.
 Colour mixes and relationships, pigment
 mixing and optical mixing, instrumentation.
 Colour inhabiting space, sounds, notes
 moving though space."

creating a space through colour and rhythms, and here music can act as a parallel if we think of how a resonating chord will echo slowly in a building, filling that space, defining its parameters, leaving an aftertaste. One should also point out that the paintings work best when the light of the ground (white or near-white), the interval between colours, can act as much as the colour bars; when there is dynamic equilibrium across the painting; when it is taut but non-compositional; when the insistent, repeated beat (as in the heart or music) is cumulative.

The question of music and its relationship to Thompson's work is something she returns to in her notebooks:

What they come out of
NOT inspired by music and music *not* the subject of these paintings.
I'm interested in a correlation between the systems, rhythms, spatial possibilities in music and abstract art. I can find relationships for myself between colour relationships, compositional rhythms and colour spacing. Indian classical ragas, ambient music, opera, choral chants.[26]

There is no direct reference to the body any more. Even by 1993, to make an association of the picture surface of *Splitting and Stroking* or *Gentle Burning* with internal body linings required some special pleading. However, the body is crucial to these works because of the visceral effect they have on the viewer.

Likewise, we should not necessarily forego landscape (urban or rural) as an influence on Thompson's work or as a way of understanding it: being in the landscape is first and foremost an experience of how we inhabit and move through space. It is intriguing to recall the situation in which the *Bar* and *Punctuation* works are made. From her studio Thompson has a view of nothing but the concrete flyover of the A40(M) – and the sky above it. Set in the most unromantic location of any studio in London, between the Metropolitan Tube line and the A40(M), beside a permanently muddy concrete works, it seems like a building site or an old Soviet new town. It is effectively placeless, but one's sense of space there is strong, although abstract rather than anchored in nature. In her studio the sky and the sky's light are echoed and caught by the vertical serrations on the concrete flyover. The grid of the bars of the crash barrier plays a delicate geometrical counterpoint with the grid of the window.

What I want to argue (and like all theoretical speculations it is just that: speculation) is that what differentiates Thompson from Noland or Riley is a baroque sense of transgression in which rupture is mediated as recurrent, albeit fluctuating, pulse, and in which the wound or the fold are associated with light rather than dark (symbolically, with life rather than the death of Caravaggio's gaping wound, and in which white as quasi-mirror ensures perpetual paradox.) Where the baroque tends to the tragic, Thompson's art is not. But this may seem bizarre: one would not instinctively think of her work as baroque; indeed, it is only in recent works that one could argue for it, although such titles as *Rive* and *Tear* are prototypically baroque. Indeed, one could argue for *Tear* as a quintessentially baroque painting in that paint, fabric and flesh are simultaneously called forth as associations, and a chasm within the painting becomes the motif.

We must turn to theory eventually to understand what makes Thompson's recent work more than formally inventive and technically proficient paintings. What is it that makes them not just interesting and pleasing to look at, but also makes us want to return? A key is in their development out of a way of painting where ambivalence of association comes not from uncertainty but as a strategy:

> I define a baroque point of view through some motifs of ambivalent, sometimes conflicting, relationality. Caravaggio's *Doubting Thomas* emblematically illuminates this general thesis. On the basis of this discussion, I develop a specific analysis of a few motifs or figures in which this baroque point of view receives artistic shape. The first, most obvious figure is the fold, the figure which Deleuze took for his title. The fold insists on surface and materiality, a materiality that promotes a realistic visual rhetoric in its wake. This materialism of the fold entails the involvement of the subject within the material experience, thus turning surface into skin in a relation which, taking my cue from Deleuze, I will call correlativist. The skin around the wound in Jesus' side is folded as if to emblematise this correlation.[27]

In the *Punctuation* works the fold becomes a recurrent pulse, white rather than black. Thompson herself has commented on how the *Punctuation* paintings are more problematic unless the ground is white or near-white. If black, it is too much of a gap, a slit. Bal's suggestion that white in the baroque and paradoxically contemporary baroque operates as a mirror may explain this: "… I contend that white is a visual and theoretical motif in that it is the site of the point of view that challenges the power of the subject and the site of the flipping of scale that challenges the stability of the object".[28]

We cannot take these paintings in: if we look at one part we lose the others. We have to look very hard to see these paintings: in particular, we cannot see the detail without losing the whole. When we are looking at the paintings they become, in effect, second-person narratives: you are trying to see this picture; you are trying to read the pulse, you struggle to hold them complete in your mind. The narrative of the painting is not in the traditional terms of I or he/she: I made the painting thus (think, for example, of Pollock's signature dripping line: we follow his hand), or he is doing this (countless traditional narrative paintings of Christ doing this or that – or this then that), but in terms of *you* remaking the painting as an experience, a narrative.[29]

One loses oneself in Thompson's works; they challenge us because in seeking to decipher or control them, we lose ourselves – we seem to become unsure of our identity. This is where the rupture of the baroque, the fold, is written large.[30] (Incidentally, this scarcely works in reproduction, where one can appreciate the colours, the harmonies and take in each painting as a whole.)

27 Mieke Bal, *Quoting Caravaggio: Contemporary Art, Preposterous History*, Chicago 1999. p. 30. As this quote shows this is a curiously layered argument: Bal, a Dutch art historian, is arguing through Deleuze, a French theorist, who is arguing through Leibniz, a German philosopher of the Baroque period. I myself am aware that I am affected here also by the arguments in recent articles, including those of Bal, as to the deeper meaning of the 'abstract' paintings of David Reed.

28 Bal 1999, p. 46.

29 It is in just such terms that Bal attempts to elucidate Reed's paintings (Bal 1999, pp. 169–207). If there is a weakness in her book it is in talking of no contemporary painter save Reed; too much time is taken up with discussing some meretricious neo-conceptual artists.

30 Another suggestion of Bal's that could be profitably followed here is that of the navel painting, a term for a whole painting that is dominated by a shocking, discrepant, discordant detail: "a 'navel' painting [is] … one whose subject is overruled by an odd detail that takes over the representation, abducting it in a different direction, resisting coherence, and thereby provoking resistance. The detail that works in this way sets in motion the process or performance of the painting that entangles the viewer across time; a process, moreover, that itself takes time, thus foregrounding the double temporality of the image and the look that takes hold over it." Bal 1999, p. 31.

Thompson discusses this in less grandiloquent terms in the notes for a lecture pasted into one of the notebooks:

> Learning to build the paintings that are not symbolic or transcendental but perceptually accessible and plastic in the sense that they build a structure of relationships that place the spectator in an analogous 'equilibrium' invited to participate in a visual interplay between weights, forces and tensions held together by a balance that is not systemic.[31]

Speculation of the sort I have initiated above is necessary but belongs to the viewer of the painting. It is not received intention. Thompson herself is wary; her reflections are pragmatic, orientated to getting the paintings right: such effect or content cannot be predetermined. The later handwritten additions or corrections (indicated below by italics) to the typewritten notes for a lecture are intriguing here:

> Desire also for them to occupy space as well as describe it. Quite literally that certain colours appear to hover above the picture plane and also that their presence as paintings.
> Size matters.
> Small Russian icons – large history paintings. Significance of size to Abstract Expressionism. *Size no longer a signifier. Interested in proportions. Most sizes now relate to very simple geometric divisions but again what feels right to the eye not purist 'systemical' or driven by geometry. 'DYNAMIC SYMMETRY' by Christine Herter.*
> Surface
> Order, control, imperfection, asymmetry, flawed repetition, *human error*.[32]

Thompson's commission to make two paintings for the new theatre at Milton Keynes has helped to initiate the most recent (*Punctuation*) works. As the wall on which they were to be sited was curved, they were painted on curved metal sheets. She has continued to use this metal as a material to paint on: it is light but also has the important merit to her – scarcely visible to others – of having a razor-sharp edge. Her concern with choosing and making paintings to fit the tall walls of the New Art Gallery Walsall for her exhibition there was to do with getting the whole space singing. One recalls that, since the Abstract Expressionists, the tendency of painters is to take over a whole room.

"I know the world through all my senses, but I understand it visually."[33] We are seeing animals: sight is our dominant sense, therefore all other senses are refracted through seeing, to a greater or lesser degree. When we look at a painting by Estelle Thompson other senses, especially touch, hearing and kinaesthesia – the sixth sense, that of movement in our own body – are referred to and activated. When one lets go and looks there is a power to these paintings. "I want to make paintings that root you to the spot, albeit for a split second, while peeling the cornea from your eyes, cleaning, washing, refreshing them."[34] These are not process paintings. They, and their effect, are not easily defined. They have a nimbus, like a cloud or aura that radiates from and around them, both in space and time, activating both the room and our own body.

31 Grid notebook, unpaginated.
32 Grid notebook, unpaginated.
33 Note to author, 2001.
34 Note to author, 2001.

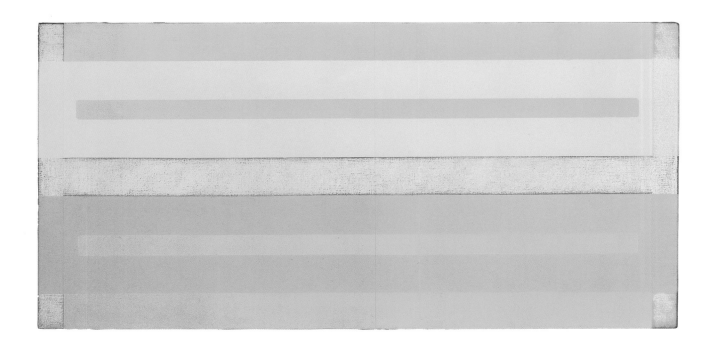

Yellow Blocks
1996
Oil on linen
61 x 122 cm

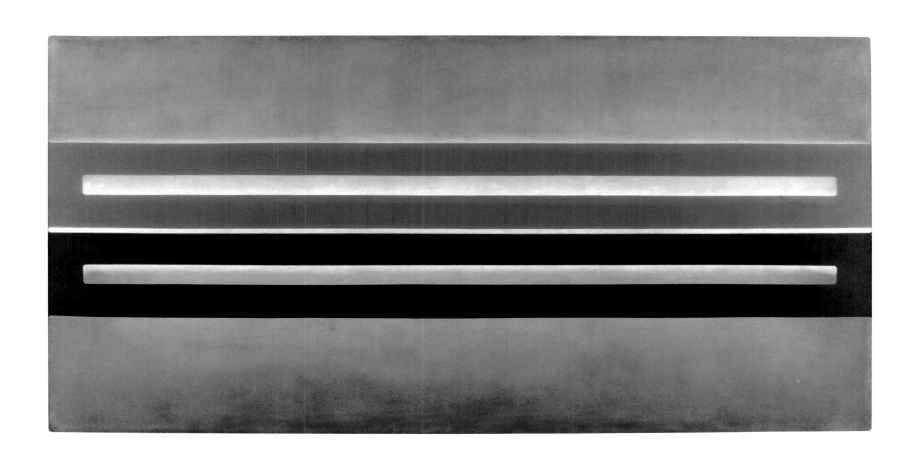

Green Blocks
1996
Oil on linen
152 x 304 cm
Private collection 23

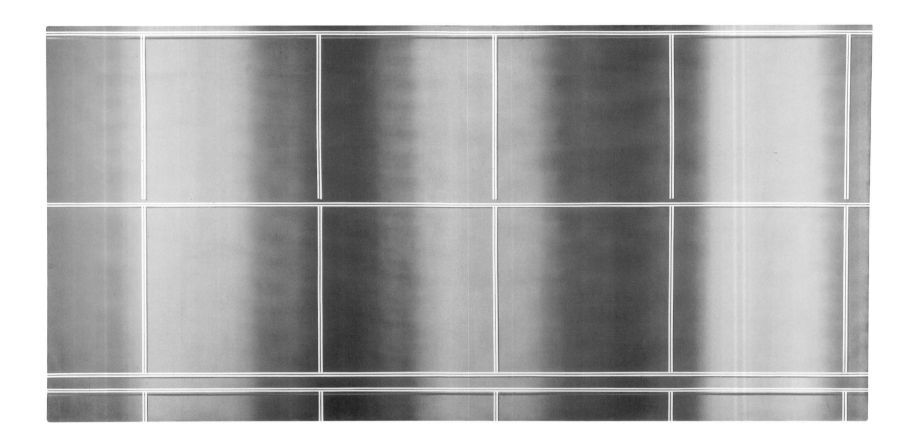

Grey Fuse
1996
Oil on linen
152 x 304 cm

Collection De Montfort University

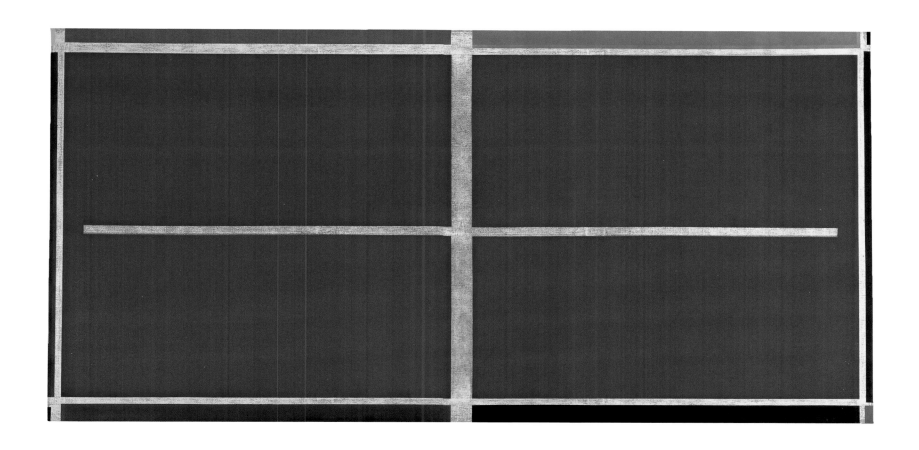

Red Flats
1996
Oil on linen
152.4 x 304.8 cm
Collection TI Group

Yellow Grid (in)

Pink Veil (on)

Blocks (through)

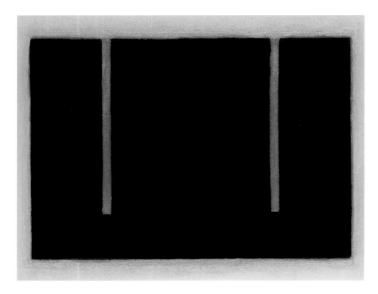

Pressed Flats (rest)

Pale Green (lift)

Orange Slice (under)

Over and Over
1996
Series of 10 aquatints, edition of 25
Printed on Somerset Satin 300 gsm by Hope (Sufference) Press, London
Sheet size 38 x 42 cm
Image size 20 x 25 cm

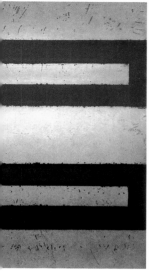

Lines (across)

Blue Flats (over)

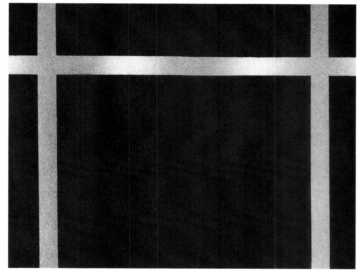

Fuse and Flat (divide)

Five Colour Grid (beyond)

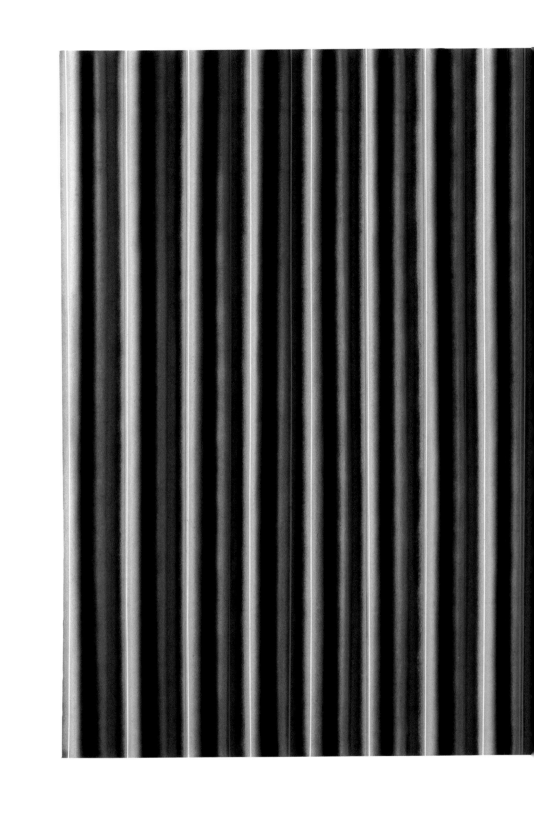

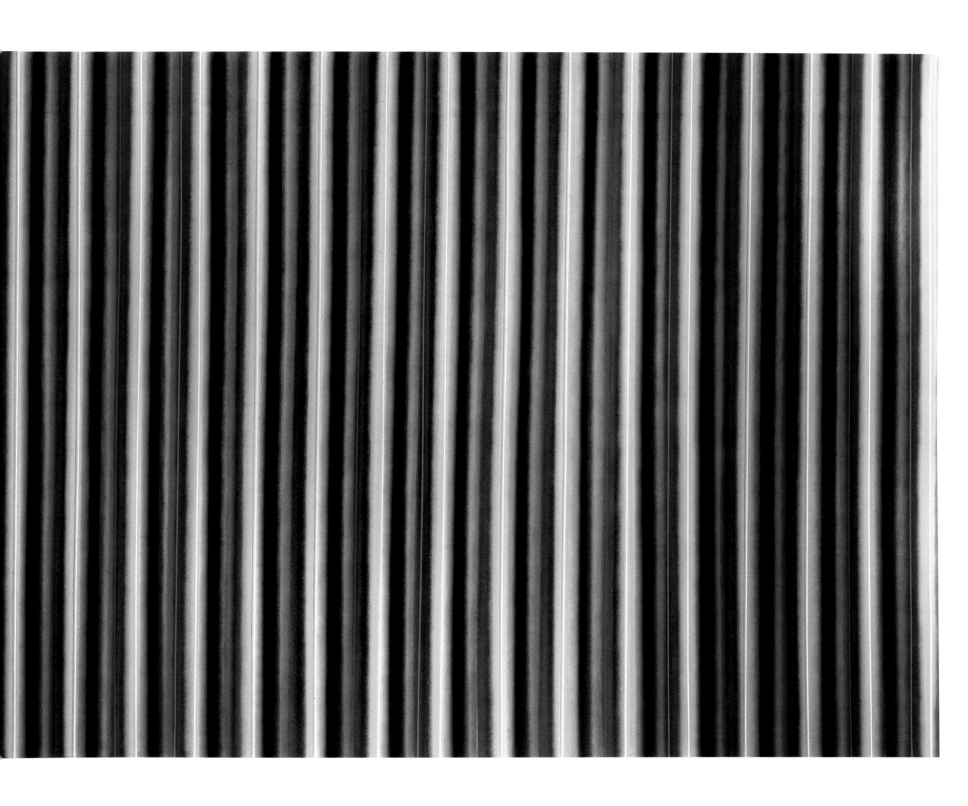

Fuse Painting: Dioxide White, Red, Yellow
1997
Oil on linen
213.4 x 426.8 cm

(detail overleaf)

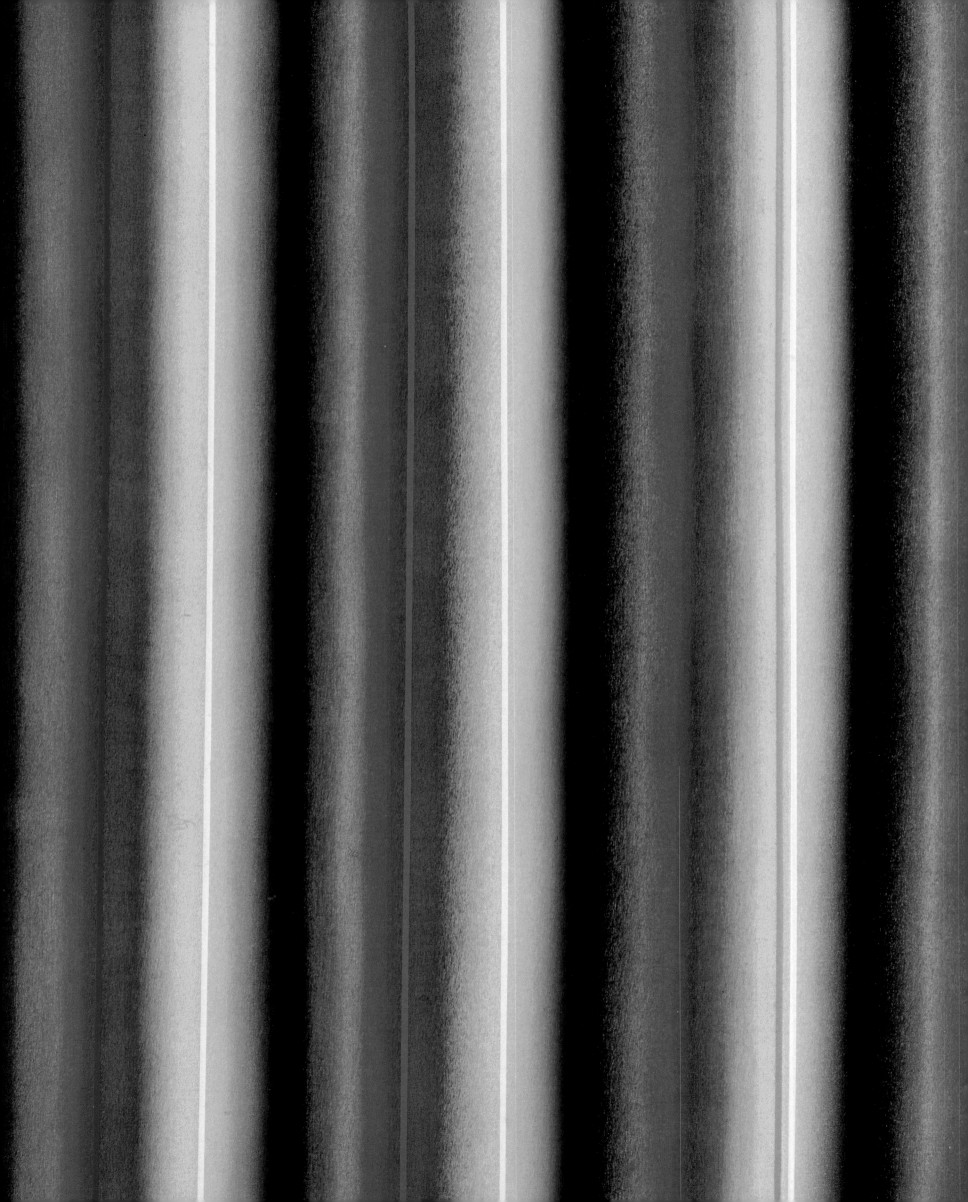

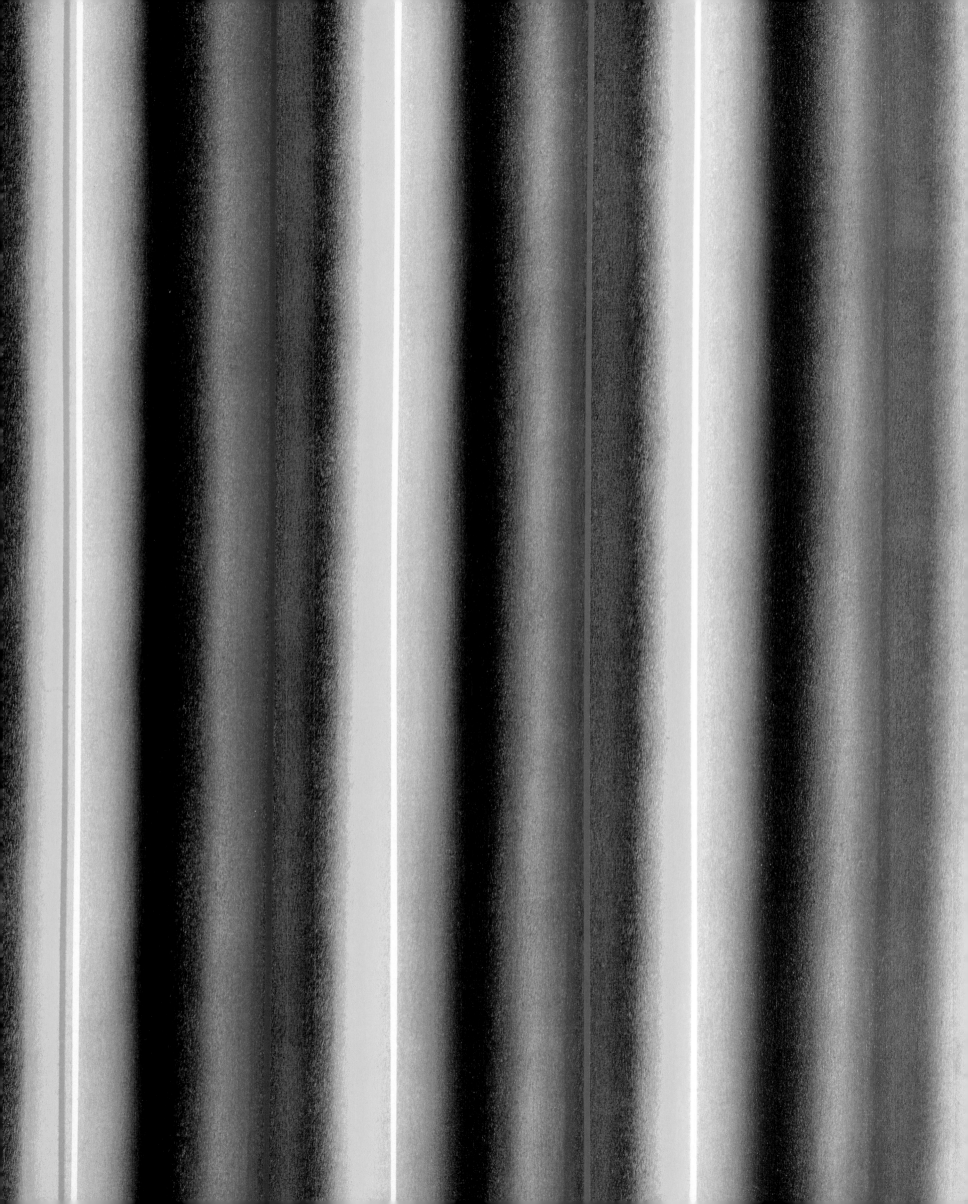

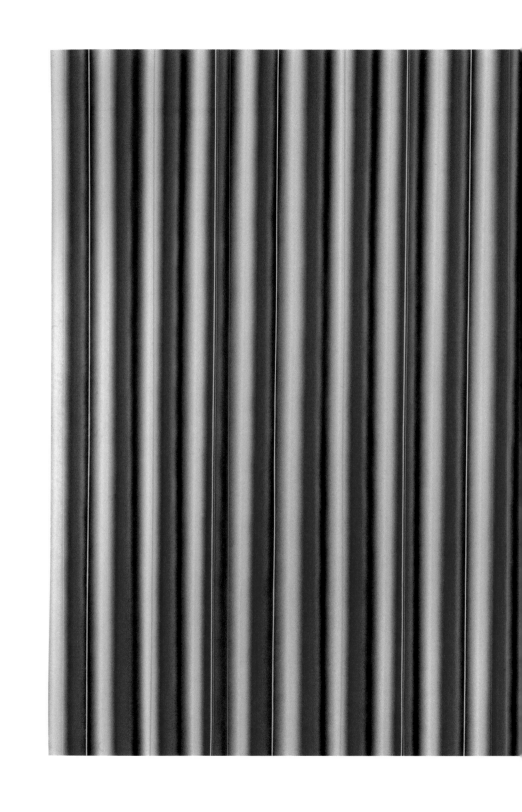

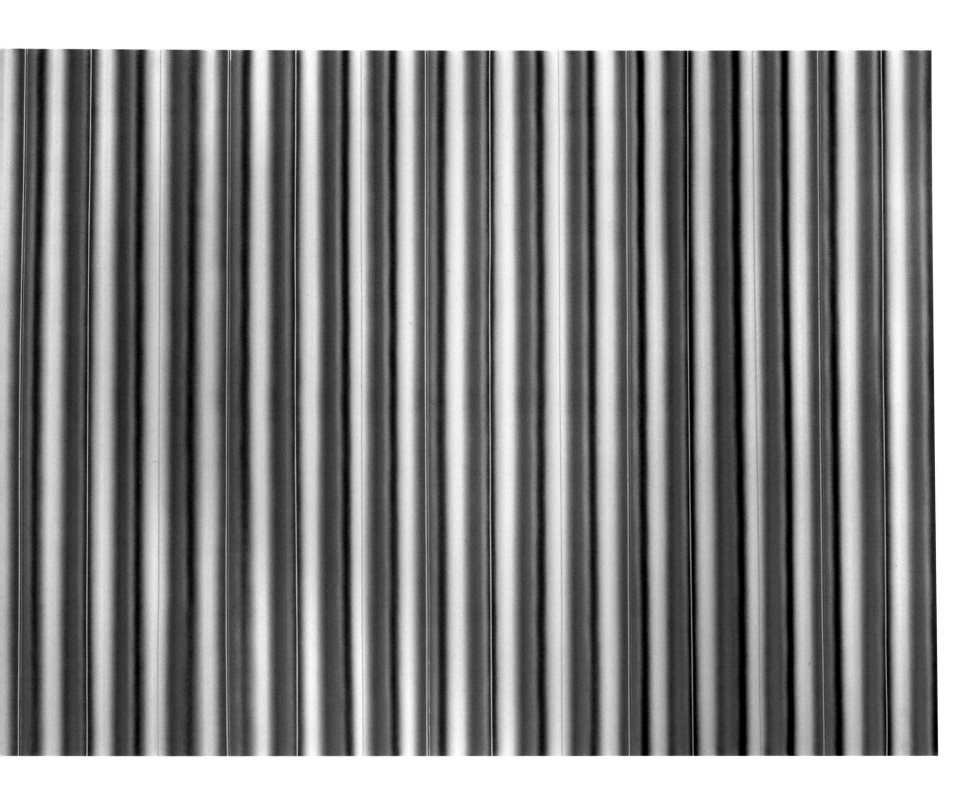

Fuse Painting: Titanium White, Yellow, Red
1997
Oil on linen
213.4 x 426.8 cm 33

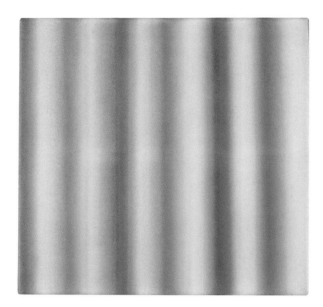 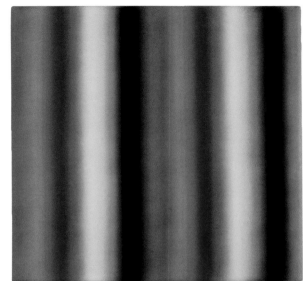 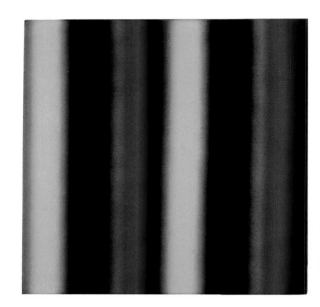

Fuse Painting: Titanium White, Indian Yellow, Sap Green,
Orange Mix
1997
Oil on linen
35.6 x 35.6 cm
Collection *Art Review*

Fuse Painting: Rose Deep, Dioxide White, Grey
1996–97
Oil on linen
35.6 x 35.6 cm
Private collection

Fuse Painting: Red, Ochre, Prussian Green, Blue
1997
Oil on linen
35.6 x 35.6 cm
Collection of the artist

34

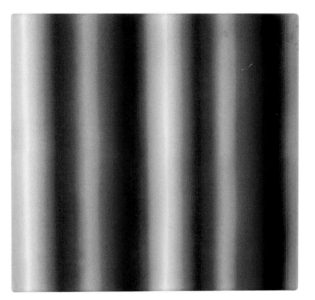 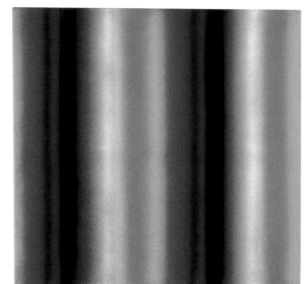 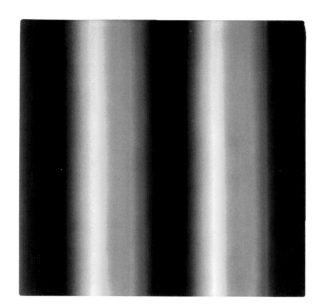

Fuse Painting: Magenta, Grey, Red, Ochre
1997
Oil on linen
35.6 x 35.6 cm
Private collection

Fuse Painting: Red, Cerulian Blue, Yellow
1997
Oil on linen
35.6 x 35.6 cm
Private collection

Fuse painting: Indigo, Indian Yellow, Magenta
1997
Oil on linen
35.6 x 35.6 cm
Private collection

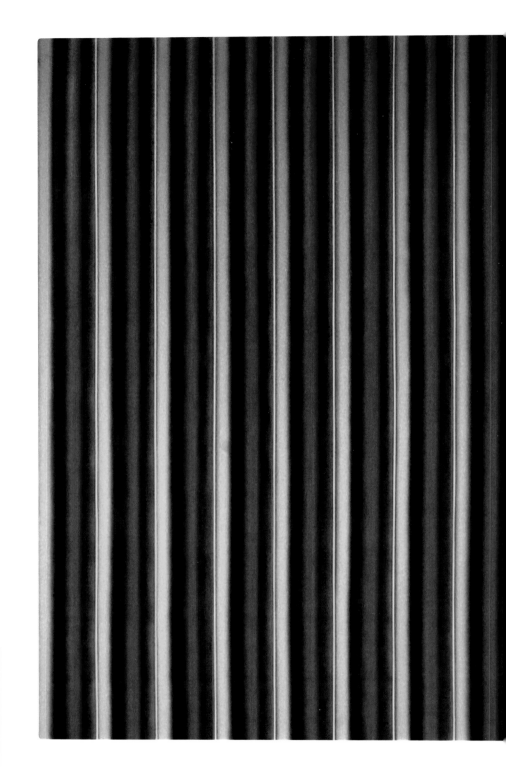

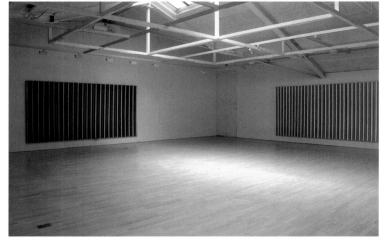

The Bracknell Gallery, Bracknell, 30 May – 28 June 1998

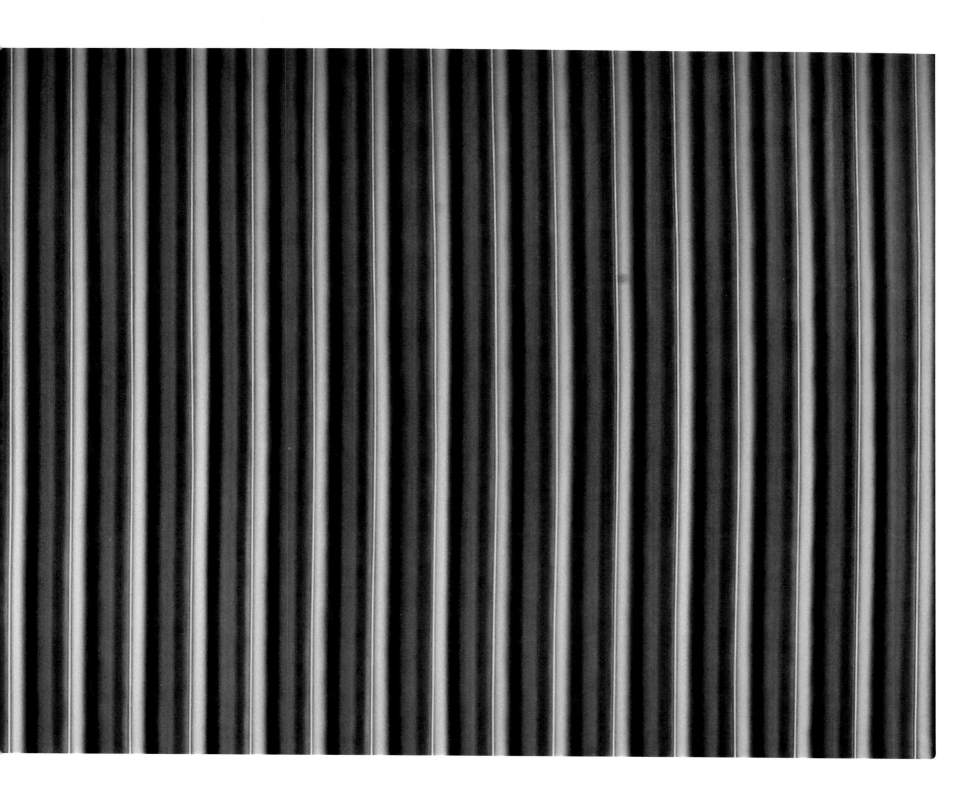

Fuse Painting: Dioxide White, Red, Ochre
1997
Oil on linen
213.4 x 426.8 cm 37

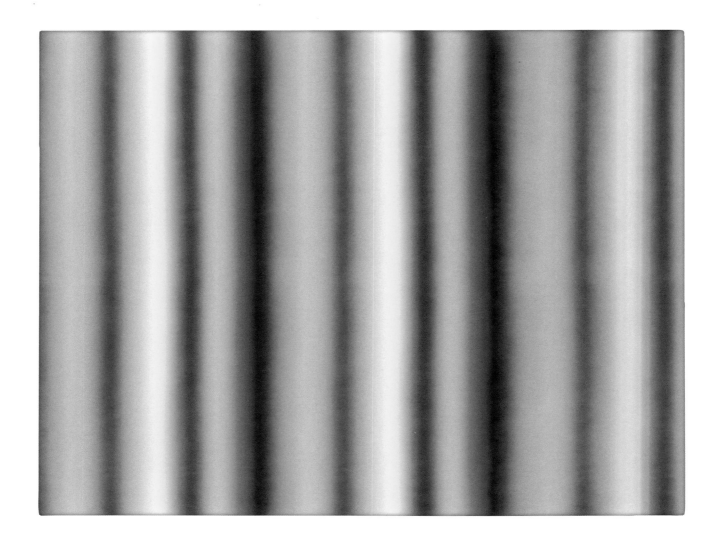

Fuse Painting
1999
Oil on panel
53.5 x 69.8 cm

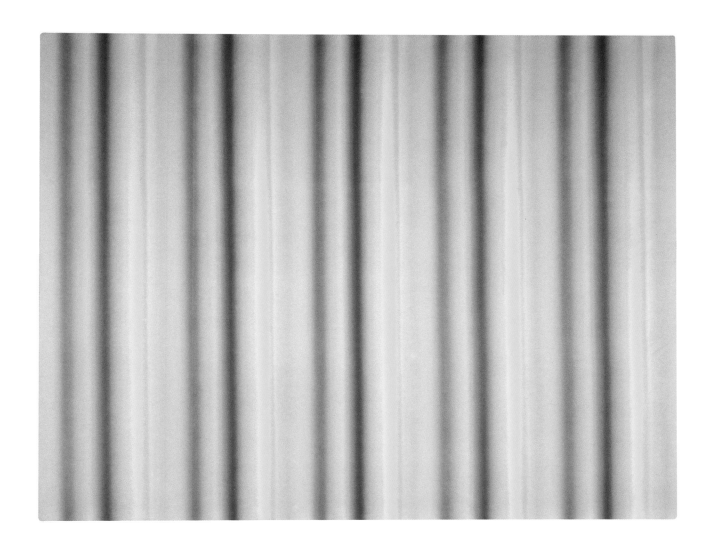

fa-la
1999
Oil on panel
60.5 x 76 cm

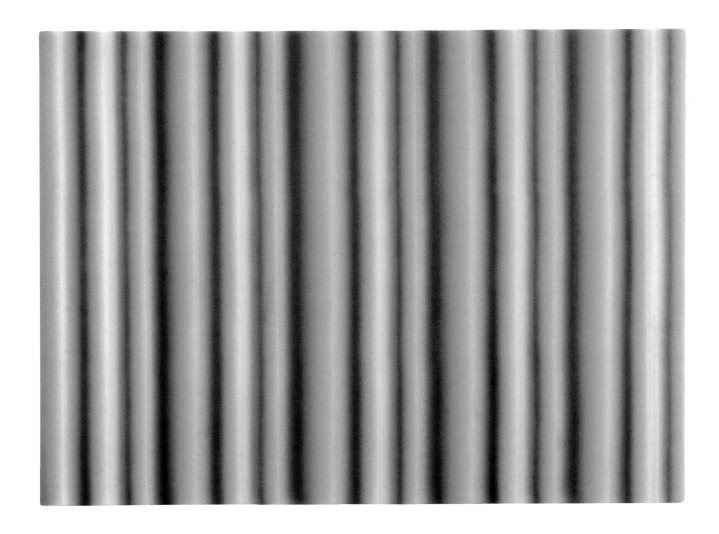

3
4
1999
Oil on panel
55.3 x 69.5 cm

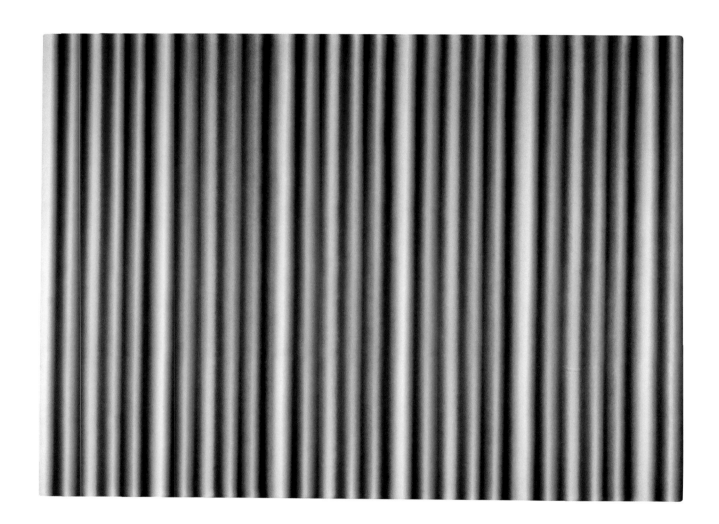

Locofoco
1999
Oil on panel
60 x 80 cm

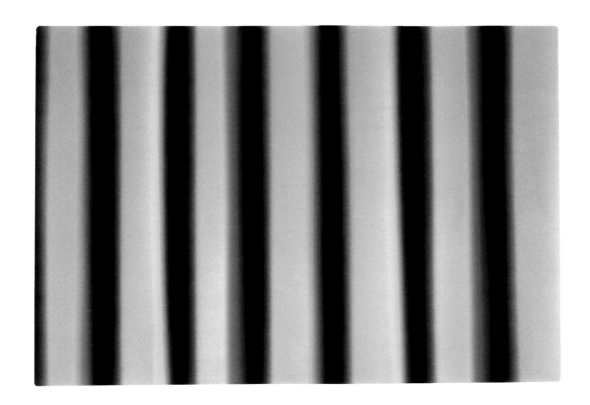

Untitled
1999
Oil on panel
34 x 44 cm

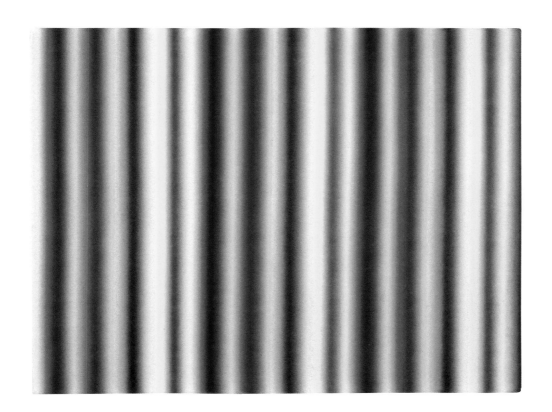

♩ = *88*
1999
Oil on panel
34 x 44 cm

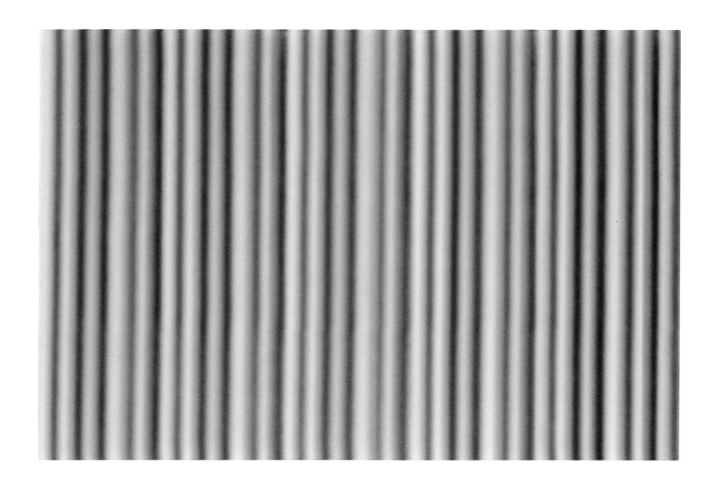

At 6s not 7s
1999
Oil on panel
61 x 88 cm
Private collection

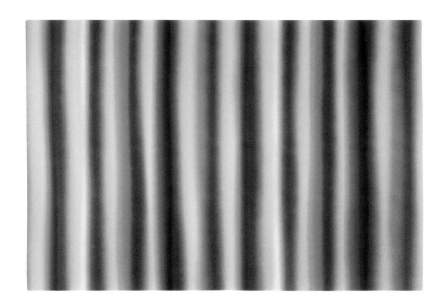

Untitled
1999
Monoprint on Somerset Satin 300 gsm
Sheet size 45 x 61 cm
Image size 26.5 x 37.3 cm 45

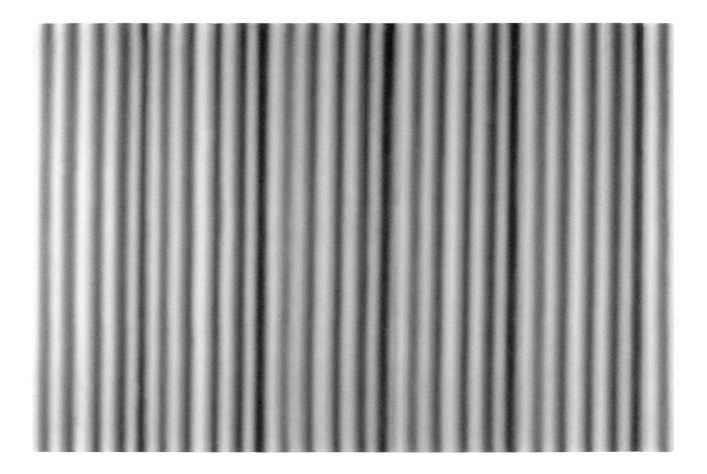

1999
Oil on panel
61 x 87 cm
Private collection

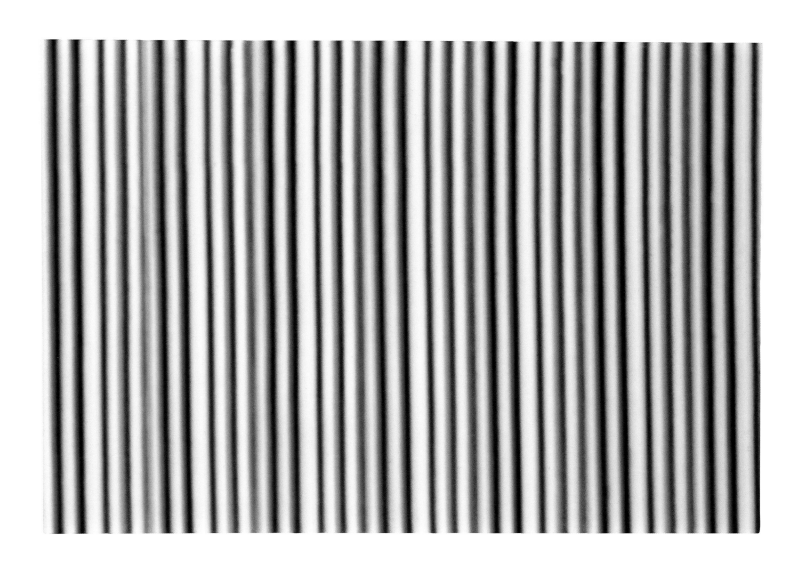

v.p.
1999
Oil on panel
75 x 105 cm

47

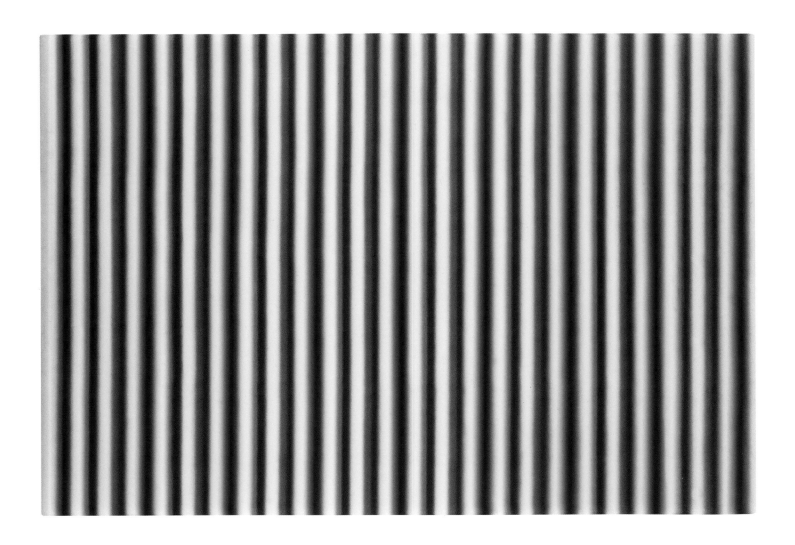

p
1999
Oil on panel
70 x 100 cm

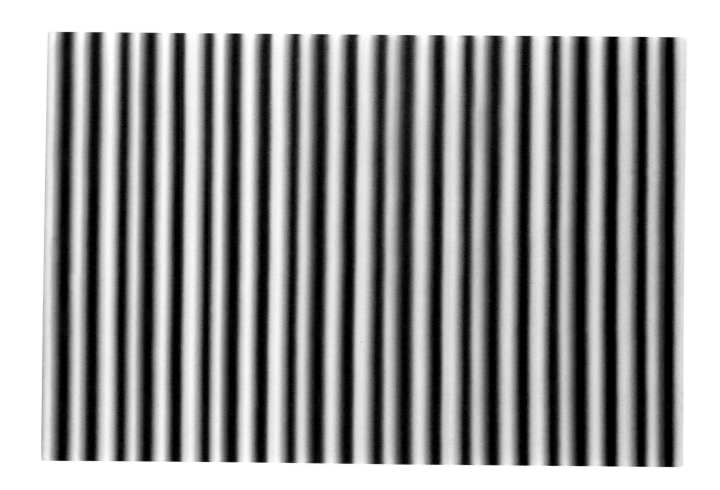

Sostenuto
1999
Oil on board
87 x 61 cm

Midsummer Rise
1999
Oil on aluminium
190 x 320 cm
Foyer, Milton Keynes Theatre

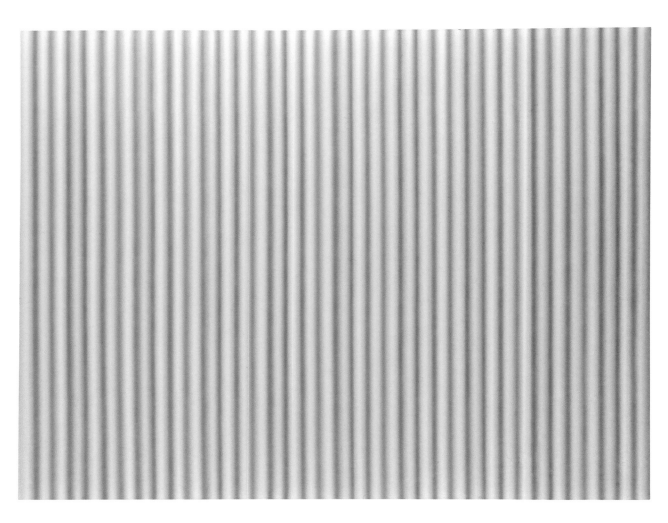

Study for Midsummer Rise
1999
Oil on panel
107 x 137 cm

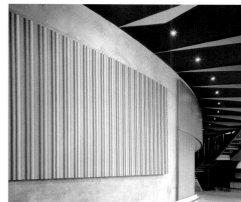

Midsummer Rise
1999
Oil on aluminium
190 x 320 cm
Foyer, Milton Keynes Theatre

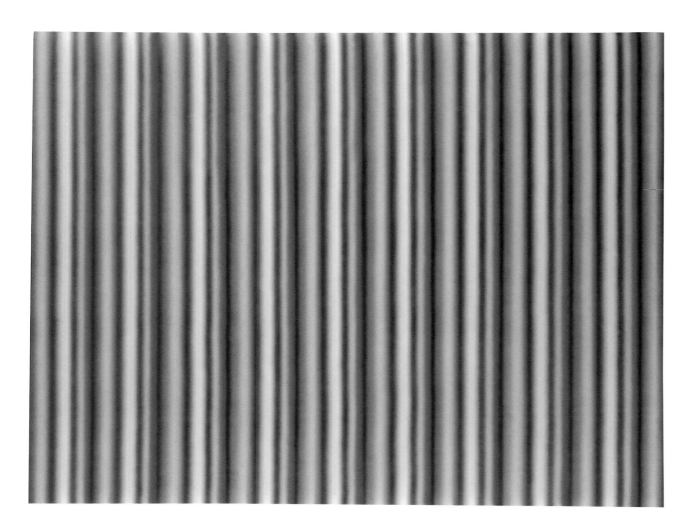

Study for Midsummer Set (first version)
1999
Oil on panel
107 x 137 cm

51

BEING HERE

New Paintings by Estelle Thompson

DEBORAH ROBINSON

Being Here (detail)
2001
Oil on aluminium
213 x 183 cm

A visit to an artist's studio is always instructive; seeing work in its place of production, at home if you like, before it is transferred to the clean environment of the gallery, where it is interrogated under the harsh glare of the spotlight. The studio is a site for work, hard work, for trial and experimentation, for meeting challenges, for frustration and despair, for exhilaration and relief. It can be a highly charged place and a visit can be fraught with tensions. A studio visit is one of the rare occasions when the viewer, too, is under scrutiny. The probing eye of the artist gauges reaction, watches the observer, creating a complex theatre of viewing, spectating, regarding, seeing … . How pertinent all of this is to these new paintings by Estelle Thompson. They make us aware of the activity of our eyes and the act of looking.

For the last four years, Estelle Thompson's paintings have been characterized by the use of vertical bands of colour. These bands are formed by lines of oil paint that blend and fuse into one another, grouped in blocks of seven to nine, which repeat. On the right edge, a darker band implies a shadow and creates an illusion of three dimensions. They suggest a reading from left to right. They are both easy and difficult to look at.

The eye, unable to find an obvious resting-place, darts and stumbles across the image. The surfaces of the paintings shimmer and blur as you try to focus. This surface is sometimes dense, viscous and opaque, sometimes transparent, fingertip-light and veiled. Either way, it is engaging and seductive to the 'tactile' eye, while the 'mapping' eye is sent on a roller-coaster ride. It is worth noting that the only sharp line on these paintings is in fact the guillotined edge of the aluminium support. The bands appear to cast a ghost image beyond the edges of the support, as if they possess a real, tangible existence. Early in my visit to Thompson's studio I am drawn to a large painting close to the entrance of the studio, and instinctively approach it, moving closer to its surface. For just a fleeting moment I am overwhelmed by the physicality of the painting. It reminds me of a sensation I once experienced when dancing to drum-and-bass music. The incessant beat was punctuated by a particularly deep sound that could be felt physically in the pit of my stomach. I am excited and exhilarated by feeling so overwhelmed again. It might be due, in part, to the coloured bands of the painting extending beyond the field of vision, which has the effect of locking the viewer within it. It is appropriate that this painting is called *Being Here* (2001).

The surface tension that characterizes much of Thompson's work is particularly intense here. The paint particles literally mesh together and the optical colour fuses as pale yellow turns to creamy pink, to sherbet red, to pure vermilion. The elements of the painting are locked together. The bands are narrow and regularly spaced; the colours have a similar intensity of hue and tone. They appear to hover a fraction above the pictorial plane. The vertical format chosen (a break from the usual horizontal emphasis) seems to exaggerate the upward as well as the downward pull of

the bars. I am made aware of where I stand, the space around me, the density and pressure of the air, my breathing: of *being here*.

300 Milliseconds (2001) is a large painting (187 x 262 cm) in landscape format. In this work the distinctive flashes of cadmium red and magenta bands attract the eye and offer an even, pulsating rhythm across the picture field. They give the eye an opportunity to rest and return, and offer an ordered sense of viewing. As with *Being Here*, and indeed with all these paintings, the sensation is one of a field of radiant, coloured light. It is significant to note how slender and consequently taut the bands have become in these most recent works. The interaction between colours becomes more and more intense by their proximity. The overall result is one of intense luminosity. Indeed, there is the sense of a backlit aura akin to that of a lightbox or film screen, pushing the colour – which is, of course, a function of light – towards us.

The titles of Thompson's earlier works identify the colours used: titanium white, madder rose, cerulean blue, ochre and so on. These titles gave way to the use of signs, symbols and abbreviations, maintaining an abstract and elusive relationship with the world of representation. The most recent titles reflect a continuing interest in perception and the relationship between painting and the viewer. Three hundred milliseconds, according to research, is the average time the eye spends resting in one place when looking at complex pictures such as paintings.[1] *Saccades* (2001) is named after the term used to describe the rapid shifts of focus when the eye scans a painting. Like *Being Here*, *Saccades* is particularly effective in activating the eye. *Parallax* (2000–01) is named after a word defined by *The Concise Oxford Dictionary* as meaning, "the apparent difference in the position or direction of an object caused when the observer's position is changed". This is certainly a characteristic of Estelle Thompson's paintings. Looked at from an acute angle, the spaces between the coloured bands appear to diminish, creating alternative rhythms. Some colours maintain their intensity, while others recede from vision. Viewed from a distance, the paintings appear more pristine and perfect – but not for long. Keep the eye fixed on the painting for more than a few seconds and the clarity of the image begins to falter and blur. Closer inspection reveals the minor imperfections that are characteristic of the work of the human hand.

Not all the titles specifically refer to the notion of looking and perception. *Wanderlust* (2000–01) is given a more lyrical title that relates to the instinctive desire to move from place to place. *Velatura* (2001) is a term from painting, referring to the process of using the palm of the hand to soften paint. *Smorzando* (2001) is a musical term, referring to a gradual fading away. These titles make enigmatic references to art, music and perception, evoking a mood without intimating more literal references.

Looking at and comparing the different paintings, it is apparent that the vocabulary used is infinitely flexible and has huge expressive potential. The artist's achievement is in selecting and ordering the vocabulary to orchestrate our experience. Although their format is similar, each painting has its own character, mood and emphasis. The painting *Susurrus* (2000; 125 x 200 cm) is of a more modest scale than *Being Here* or *300 Milliseconds*, and, with its muted pinks and mauves, and no clearly dominant colour, it has a gentle and intimate feel. In contrast, *Citrine* (2000–01) has an acid and bitter appearance. We are made aware of the active nature of the ground and its effect on the bands of colour. The lime-green ground colour sharpens the magenta, scarlet and turquoise bands.

1 In his essay 'Time to Look' in the catalogue to the exhibition *Telling Time* at the National Gallery, London (2000–01), Alexander Sturgis refers to 'fixations' – the eye-pauses when viewing and information is taken in.

The smaller paintings, although not studies in the usual sense of the word, act for Thompson as a means to comprehend more fully the ways in which certain combinations of colour and spacing will work together. They are never simply copied on a larger scale, and changes occur, inevitably, in the transition from small to large. It is revealing to compare some of these 'studies' with their larger counterparts. The slightest variation in size, scale, format, colour, tone, order and space have the potential to alter dramatically the atmosphere of the painting. In the study for *Being Here*, the dark shadows, which help to give formal definition to the coloured bands, are denser than in the large painting, which is a considerably lighter and more airy painting.

Selecting and mixing colour is a vital part of Thompson's art. A table in her studio is covered with a huge array of chromatically ordered tubes of paint. Using prepared oil paint, she mixes colour and retubes it. She will often try to identify the component parts of a colour: what makes a particular green so vibrant or bitter or mellow. Unmix it to remix it. There are certain key colours and degrees of opacity and transparency – magenta, various reds, chrome yellows and manmade dye-range blues and greens – that form part of the artist's personal vocabulary. It is important to emphasize that this vocabulary does not have its basis in any formal recourse to colour theory; rather, it is based on continuous empirical study.

These paintings can be fully understood only if we allow their intellectual, emotional and physical impact to take hold of us as we stand in front of them. Their reproduction, though useful, cannot compensate us for experiencing these paintings directly. They need you to know them by being with them, by being there; indeed, by *being here*.

Sytallic
2000
Oil on panel
60 x 80 cm

57

Vib.
1999–2000
Oil on panel
70 x 100 cm

61

PIO
2000
Oil on panel
60 x 80 cm

63

Angel Row Gallery, Nottingham, 3 May – 10 June 2000

Candent
1999–2000
Oil on panel
70 x 100 cm

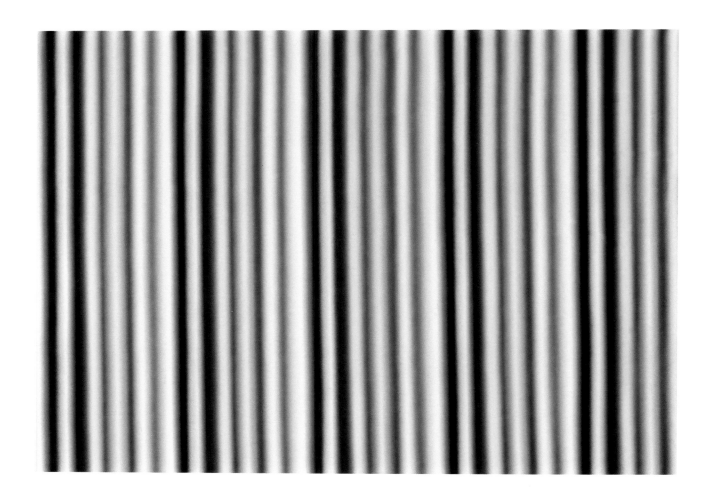

Velatura
1999–2000
Oil on panel
60 x 80 cm

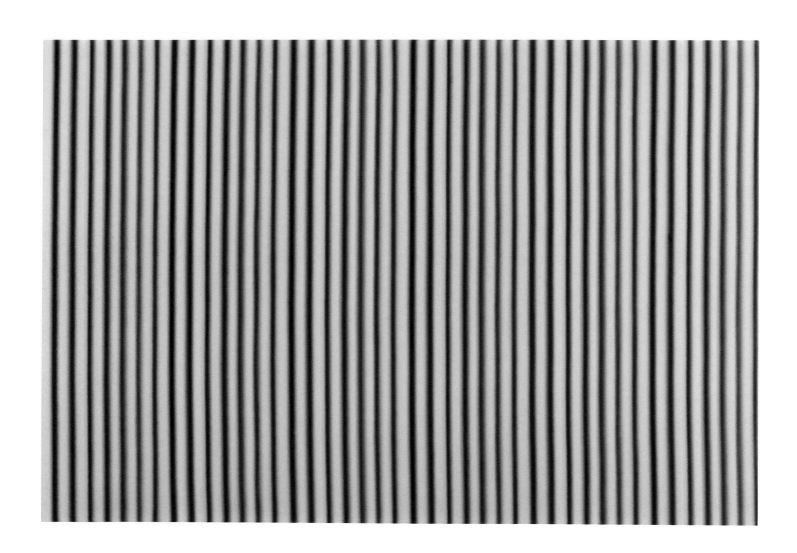

Untitled
2001
Oil on panel
70 x 100 cm

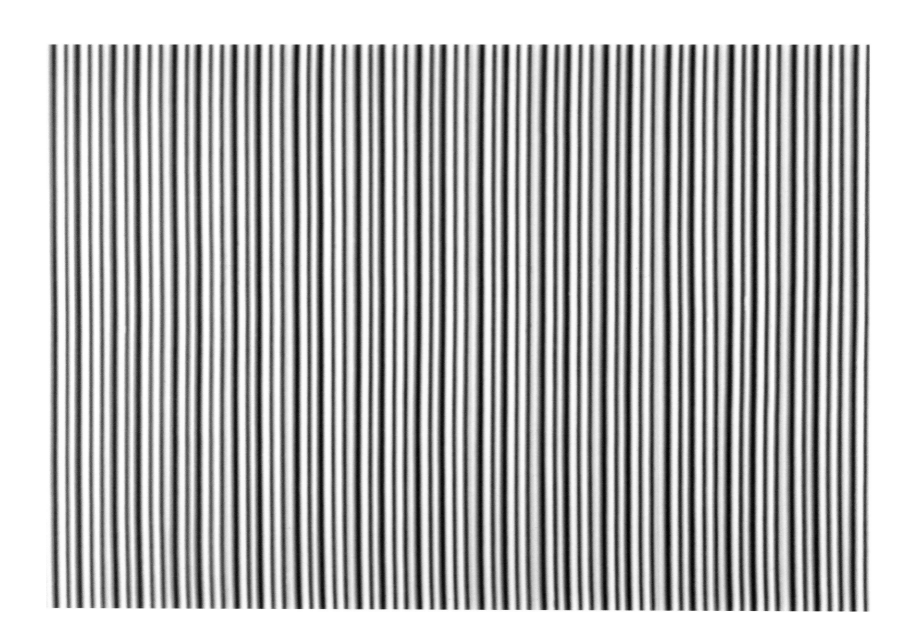

2000
Oil on aluminium
151 x 200 cm
Private collection 71

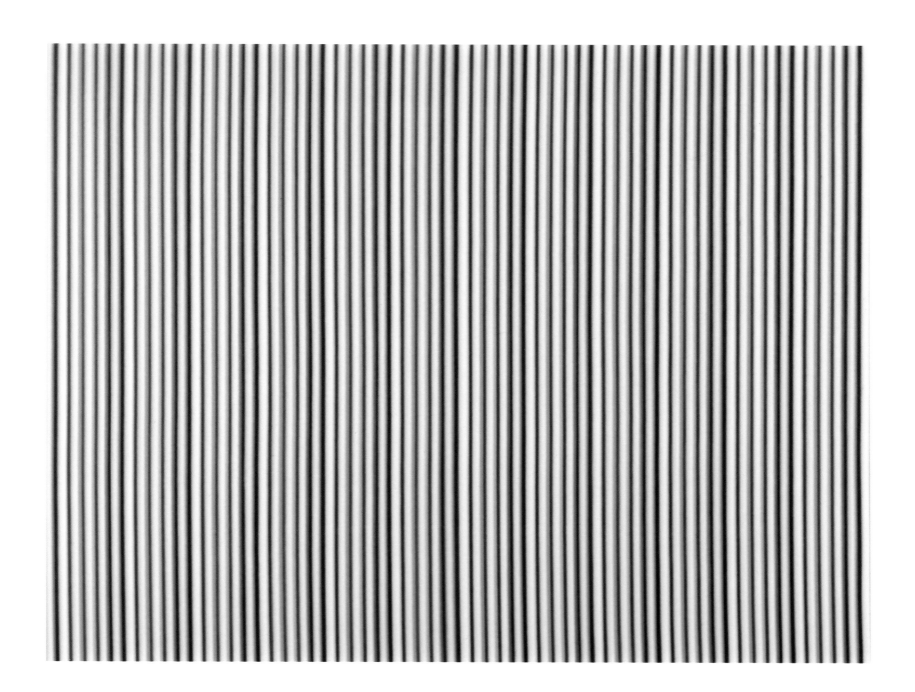

REM
2000
Oil on aluminium
151 x 193.5 cm

73

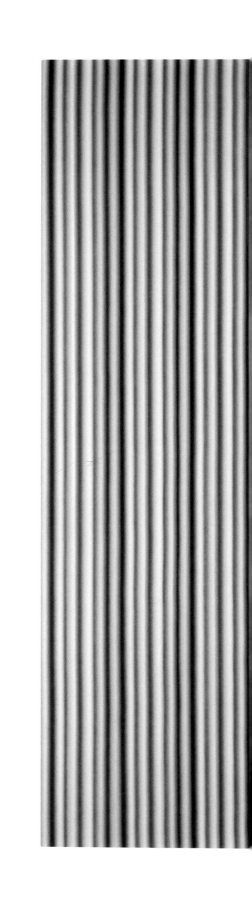

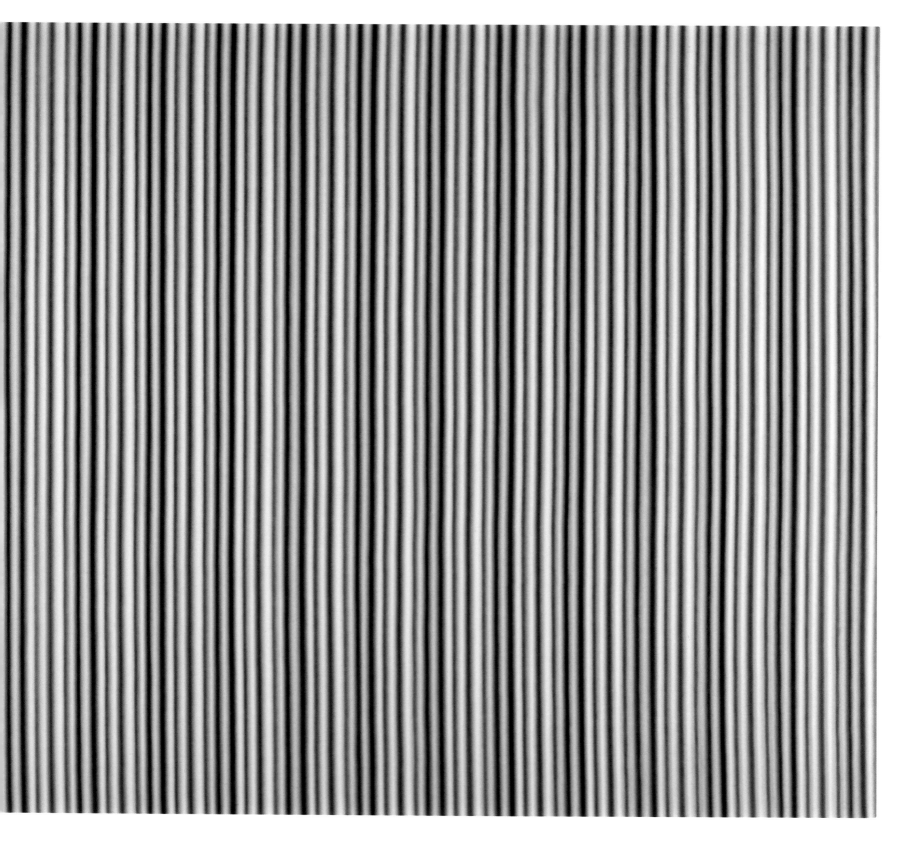

∞

2000

Oil on aluminium

187 x 262 cm

75

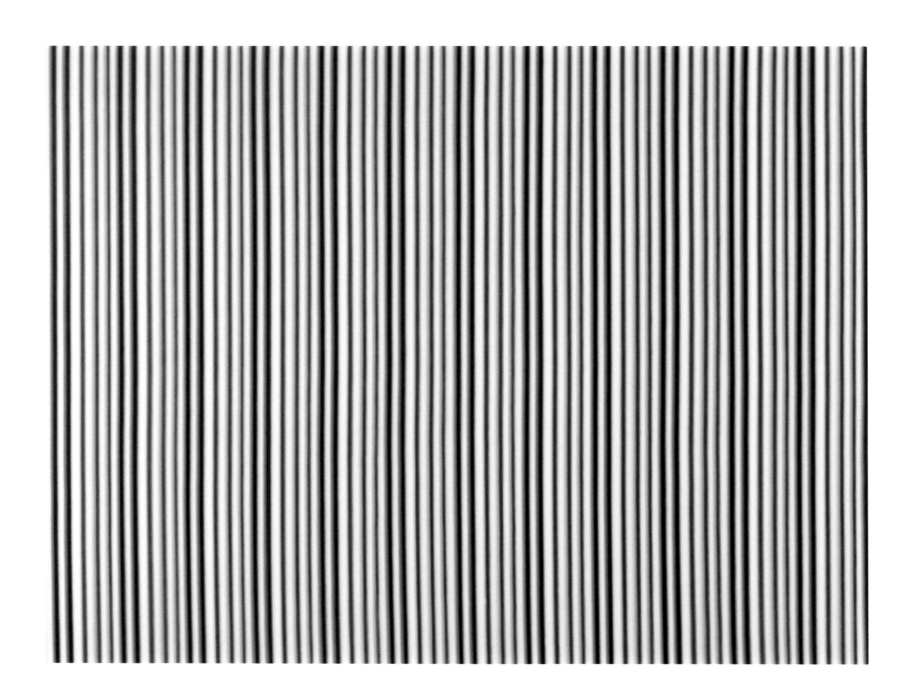

0°C
2000
Oil on aluminium
151 x 193.5 cm

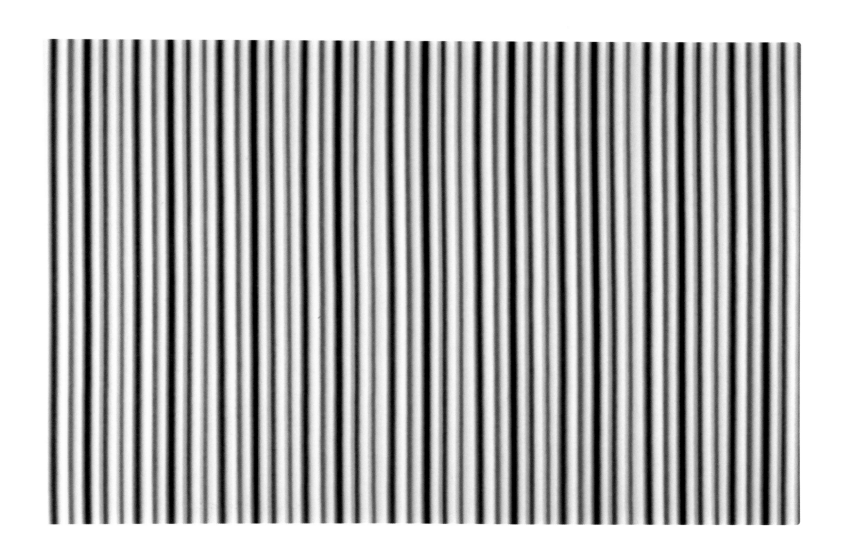

X'd
1999
Oil on aluminium
100 x 150 cm 79

Concord Discord
2000
Oil on panel
70 x 100 cm

Stet
2000
Oil on panel
75 x 105 cm

Susurrus
2000
Oil on aluminium
125 x 200 cm

(detail opposite)　85

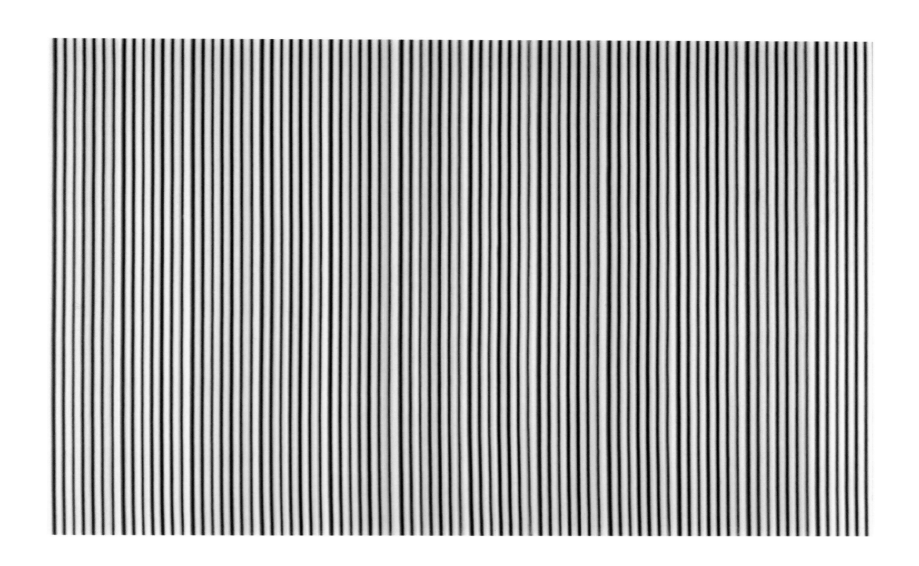

Citrine
2000–01
Oil on aluminium
125 x 200 cm

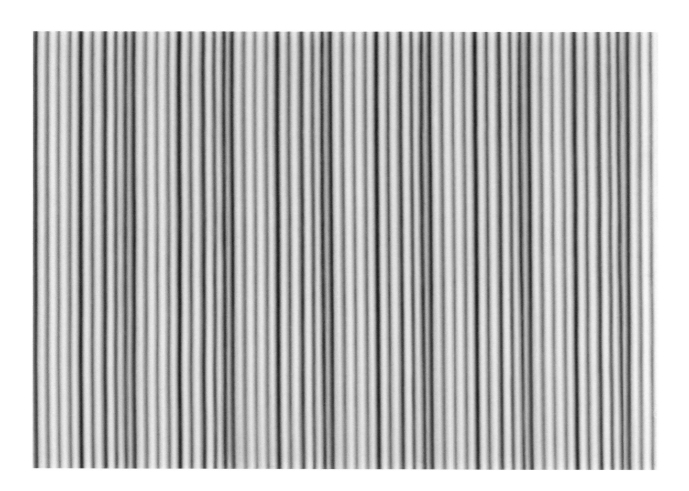

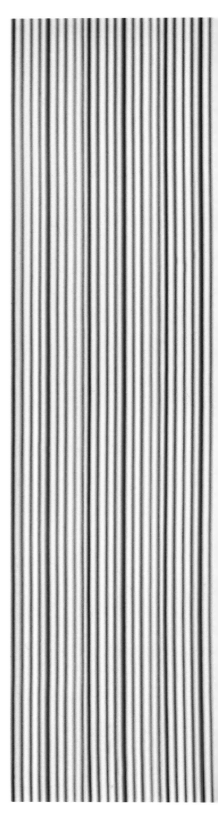

Study for 300 Milliseconds
2000
Oil on panel
80 x 110 cm

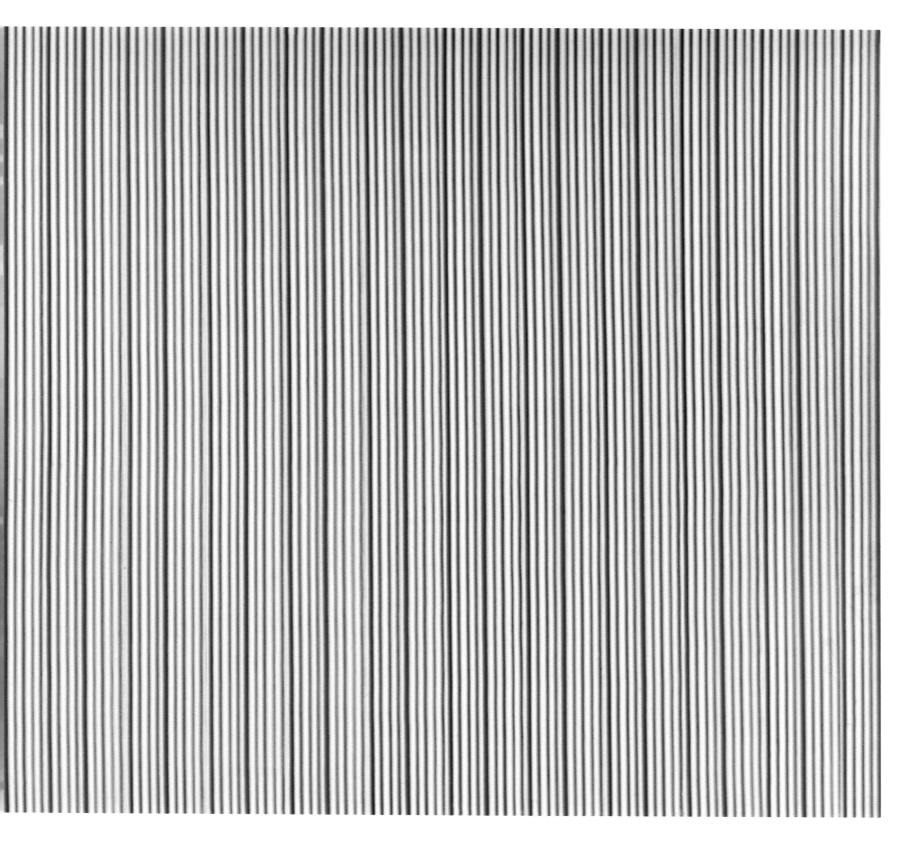

300 Milliseconds
2000–01
Oil on aluminium
187 x 262 cm

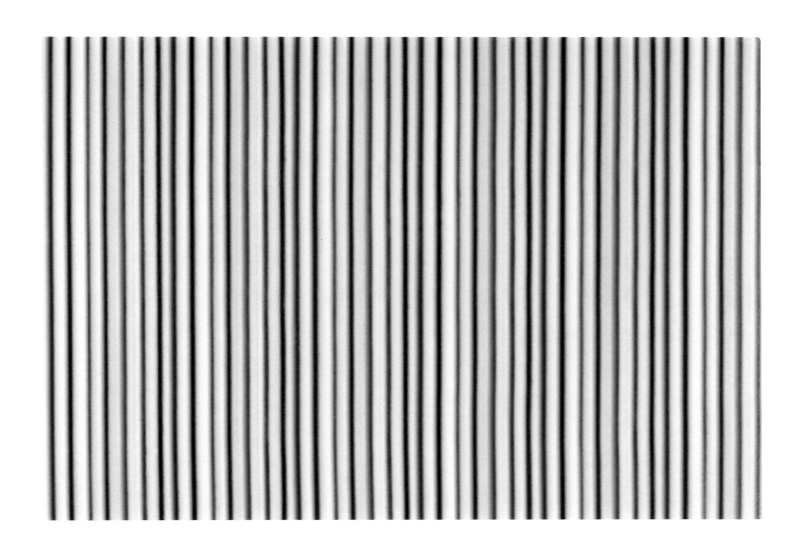

Parallax
2000–01
Oil on panel
70 x 100 cm

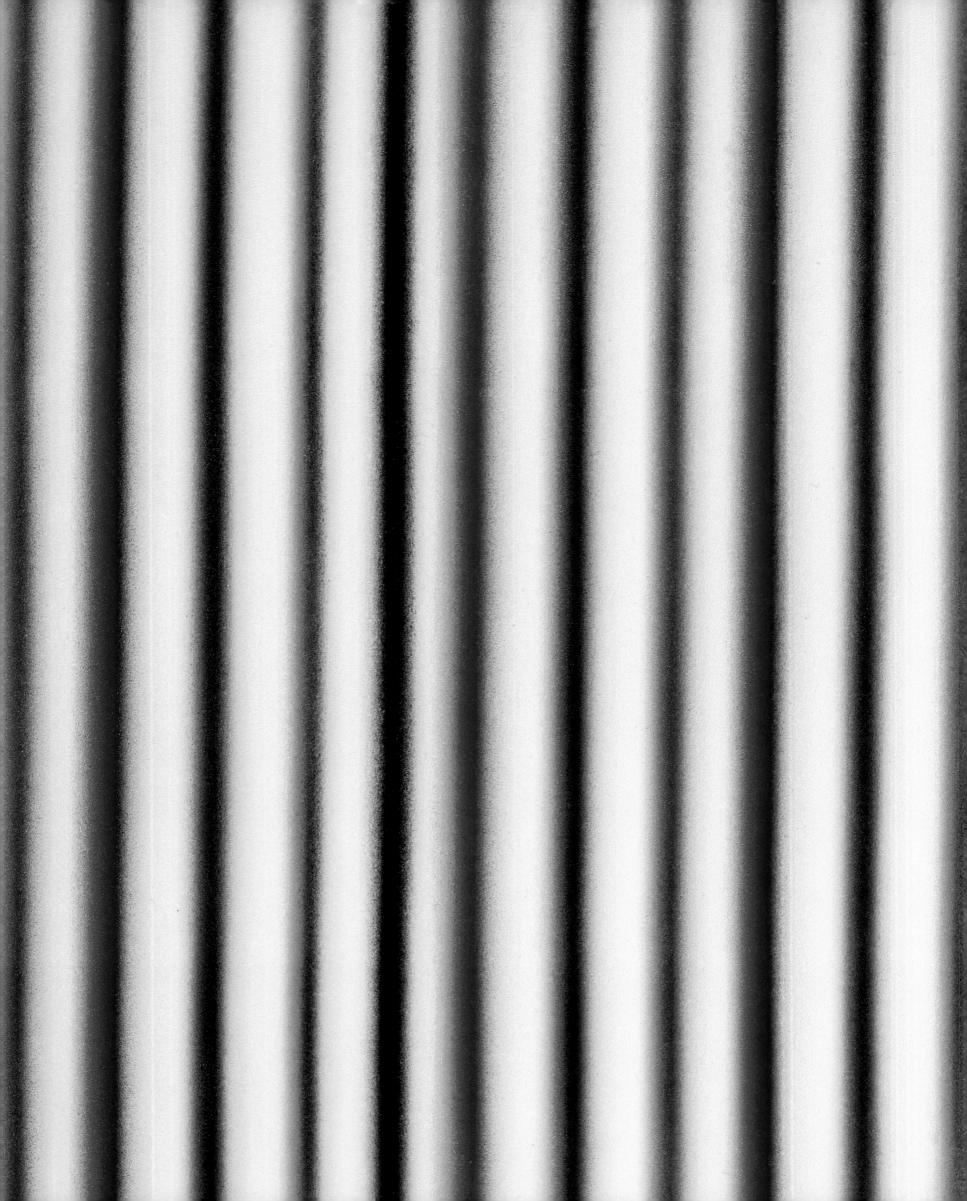

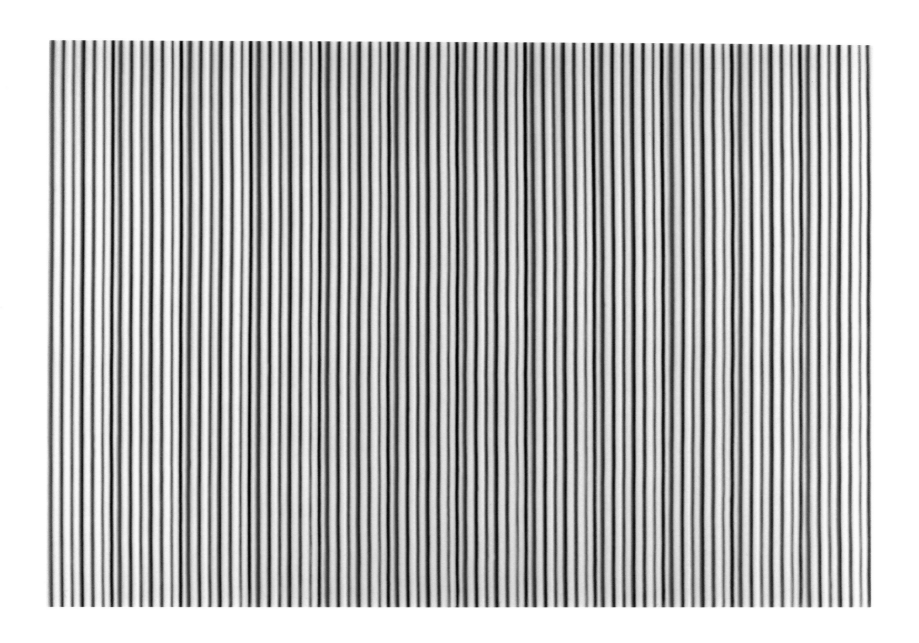

Wanderlust
2000–01
Oil on aluminium
150 x 210 cm

(detail opposite) 93

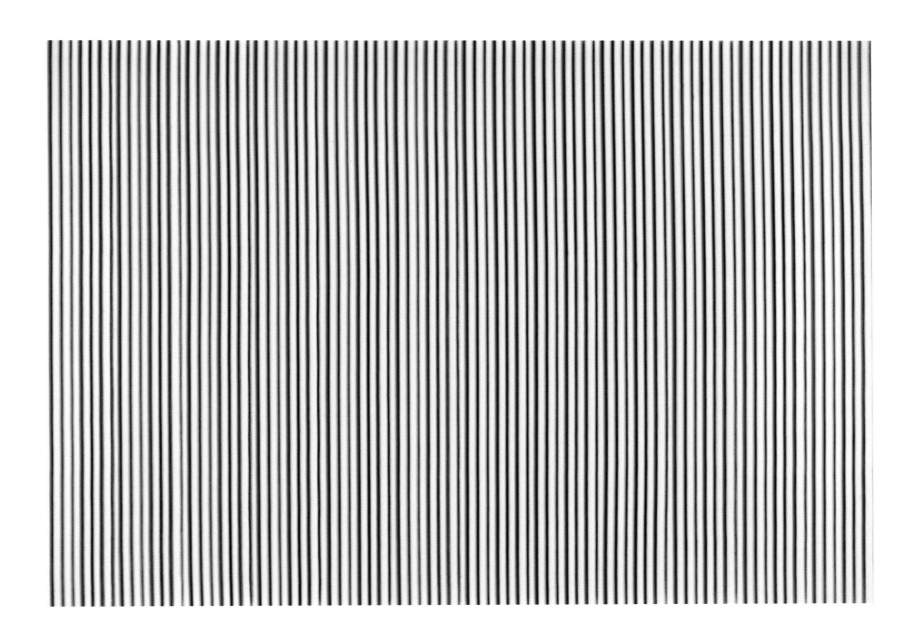

Saccades
2001
Oil on aluminium
150 x 210 cm

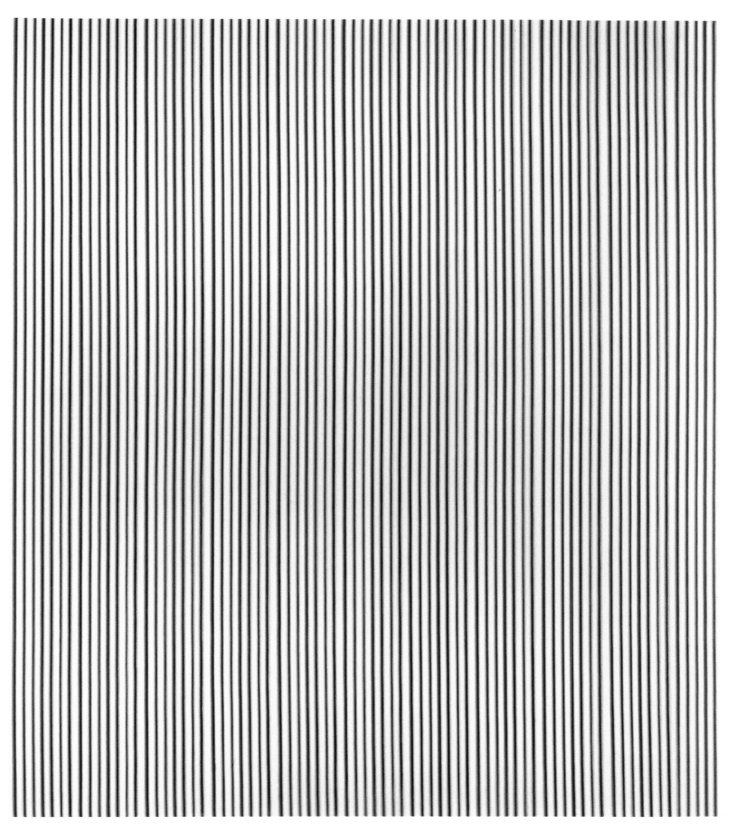

Being Here
2001
Oil on aluminium
213 x 183 cm

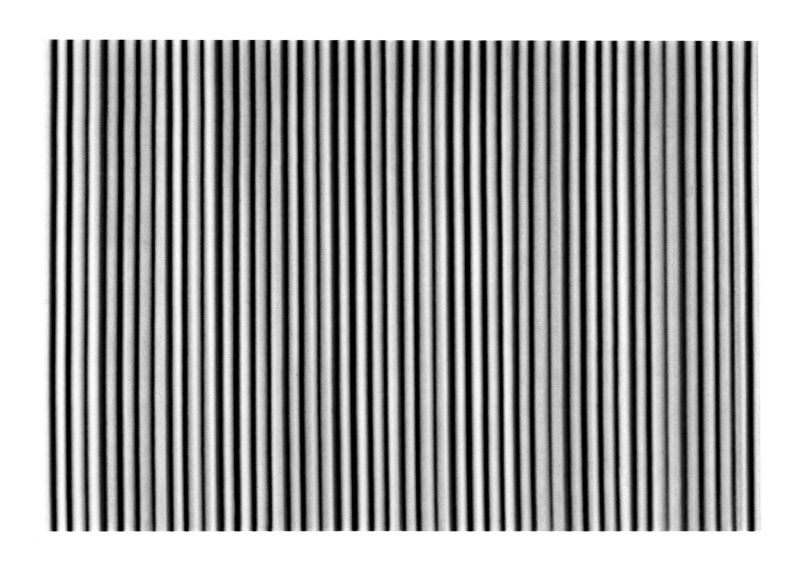

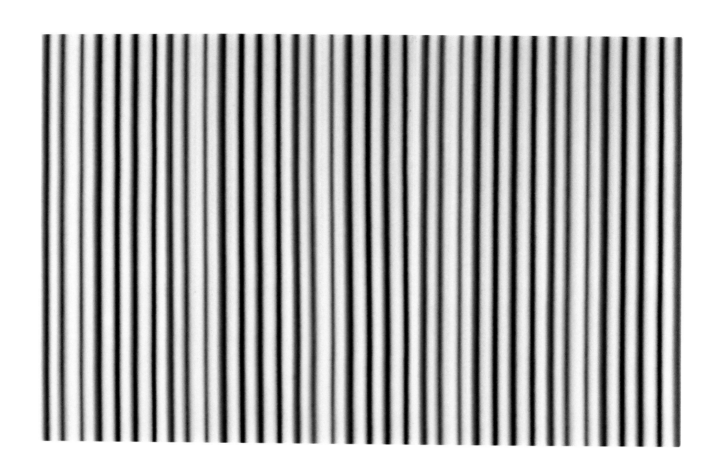

Lumen
2000
Oil on panel
60 x 90 cm

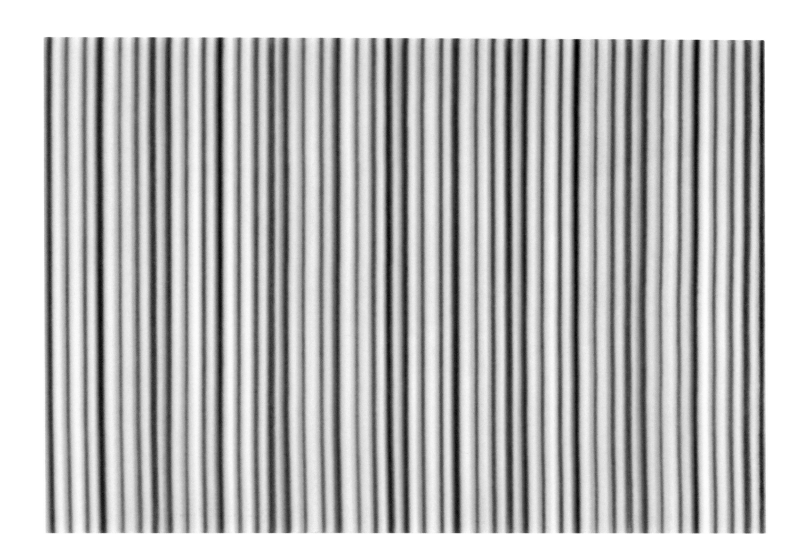

Dot and Tickle
2000–01
Oil on panel
75 x 105 cm

103

Skimmy
2001
Oil on panel
60 x 80 cm

Smorzando
2001
Oil on panel
70 x 100 cm

Drop Shadow
2001
Oil on panel
80 x 110 cm

Clos
2001
Oil on panel
70 x 100 cm

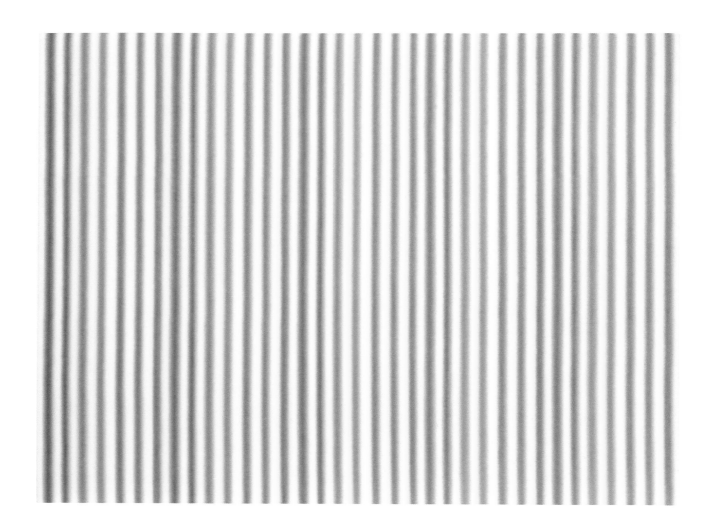

Chrisma
2001
Oil on panel
60 x 80 cm

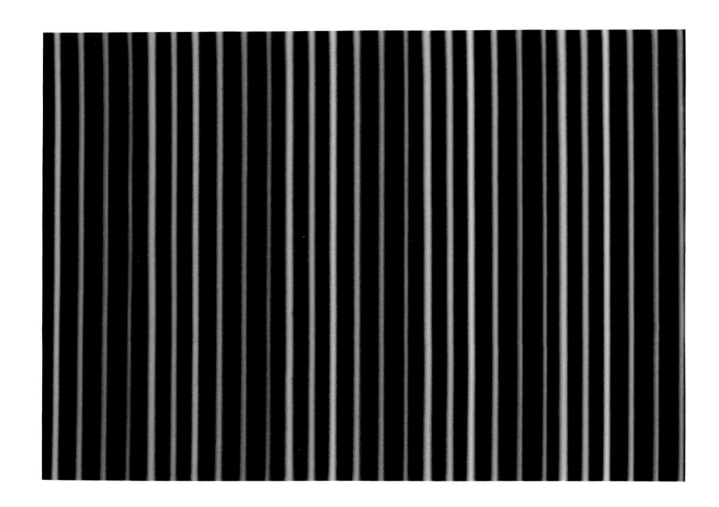

Regur
2000–01
Oil on panel
60.5 x 83.5 cm

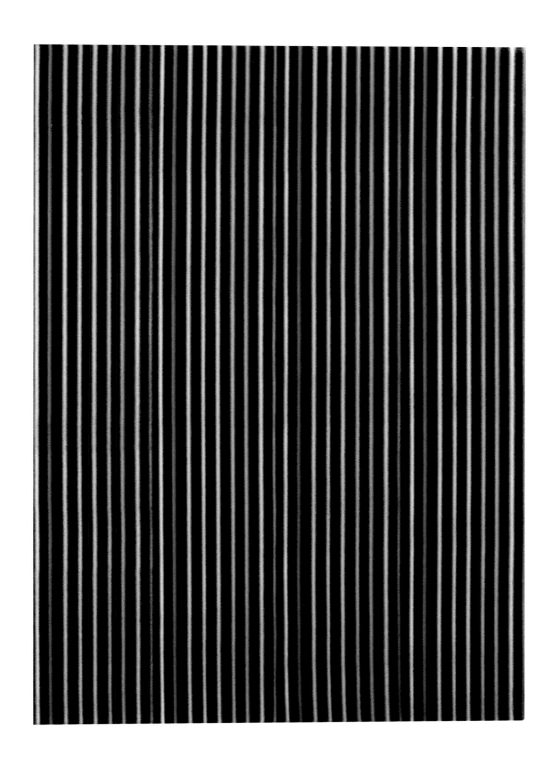

Clutter / Clatter
2001
Oil on panel
100 x 70 cm

Untitled No. 1
2000
Monotype
Sheet size 48 x 84 cm
Image size 17.5 x 55.5 cm
Printed on Somerset Satin paper
by Hope (Sufferance) Press, London

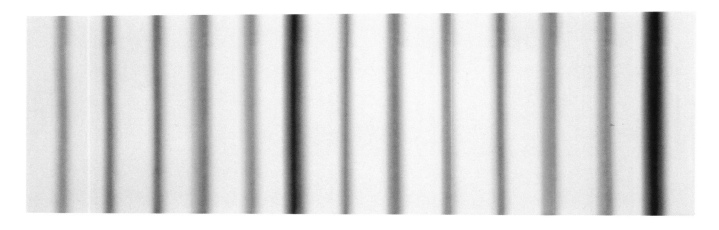

Untitled No. 2
2000
Monotype
Sheet size 48 x 84 cm
Image size 17.5 x 55.5 cm
Printed on Somerset Satin paper
by Hope (Sufferance) Press, London

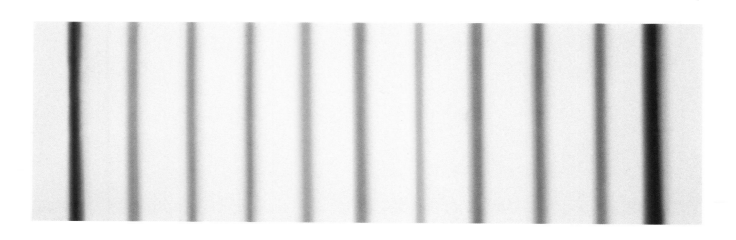

Untitled No. 3
2000
Monotype
Sheet size 48 x 84 cm
Image size 17.5 x 55.5 cm
Printed on Somerset Satin paper
by Hope (Sufferance) Press, London

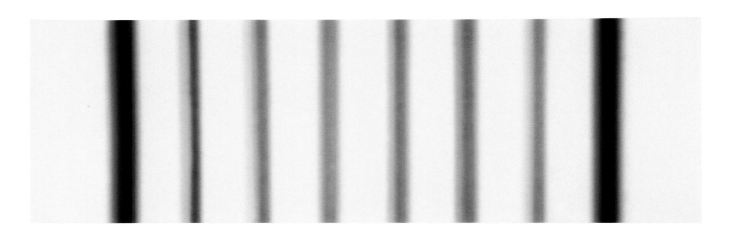

Untitled No. 4
2000
Monotype
Sheet size 48 x 84 cm
Image size 17.5 x 55.5 cm
Printed on Somerset Satin paper
by Hope (Sufferance) Press, London

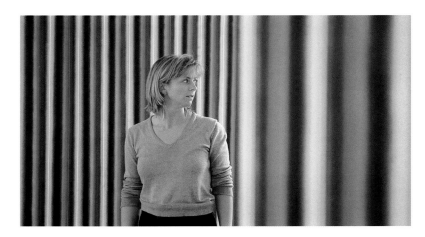

Estelle Thompson was born in 1960 in West Bromwich.
She studied at Sheffield City Polytechnic from 1979 to 1982
and at the Royal College of Art, London, from 1983 to 1986.
She lives and works in London.

An asterisk (*) indicates the publication of a related exhibition catalogue

SOLO EXHIBITIONS

2001	The New Art Gallery Walsall
	Purdy Hicks Gallery, London
2000	Angel Row Gallery, Nottingham*
1999	Purdy Hicks Gallery, London
	Galerie Helmut Pabst, Frankfurt
1998	*Fuse Paintings*, touring to Usher Gallery, Lincoln;

1998 *Fuse Paintings*, touring to Usher Gallery, Lincoln;
 Mead Gallery, University of Warwick; The Bracknell Gallery, Bracknell;
 Purdy Hicks Gallery, London*

 Fuse Monotypes, Purdy Hicks Gallery, London

1997 Abbot Hall Art Gallery, Kendal

1996 Purdy Hicks Gallery, London*

 Galerie Helmut Pabst, Frankfurt*

1993 Purdy Hicks Gallery, London, touring to Winchester Gallery, Winchester;
 Towner Art Gallery, Eastbourne; Darlington Arts Centre, Darlington*

1992 Castlefield Gallery, Manchester

1991 Pomeroy Purdy Gallery, London*

1990 Eastbourne Clark Gallery, West Palm Beach, Florida

1989 Pomeroy Purdy Gallery, London*

 Eastbourne Clark Gallery, West Palm Beach, Florida

SELECTED GROUP EXHIBITIONS

2001 *British Abstract Painting*, Flowers East, London

2000 *Blue: Borrowed and New,* The New Art Gallery Walsall*
 (gallery's inaugural exhibition)

 Einmal Leiwand, einmal Papier, Galerie Helmut Pabst, Frankfurt

1999 *Recent Graphic Work*, Purdy Hicks Gallery, London*

1998–99 *History*, The Mag Collection, Ferens Art Gallery, Hull; Fruitmarket Gallery,
 Edinburgh; Cartwright Hall, Bradford; Orleans House, Twickenham;
 Towner Art Gallery, Eastbourne, York City Art Gallery;
 Laing Art Gallery, Newcastle upon Tyne*

1988 *Etchings from Hope (Sufferance) Press*, Marlborough Graphics, London

 New York Publishers Fair, Brooke Alexander Editions, New York

1997 *The Print Show*, Flowers Graphics, London

 Prints, Purdy Hicks Gallery, London

 Shadow of Life, Art '97, London*

1996 *Re-opening Exhibition*, Purdy Hicks Gallery, London

1995 *Cabinet Paintings*, Jason Rhodes Gallery, London

 The Question of Scale, Winchester Gallery, Winchester; Arnolfini, Bristol*

 Six British Painters, Galerie Helmut Pabst, Frankfurt

1994 *Castlefield Gallery, 10th Anniversary*, Whitworth Art Gallery,
 University of Manchester

1993–94 *Moving into View: Recent British Painting*, Royal Festival Hall, London,
 touring to Darlington Arts Centre; Chapter, Cardiff; Oriel Gallery, Mold;
 Newlyn Orion Gallery, Penzance; University of Northumbria,
 Newcastle upon Tyne; Drumcroon Arts Centre, Wigan;
 Harrogate Museum and Art Gallery; Victoria Art Gallery, Bath

1993 *The Critics Choice: New British Art*, Christie's, London*

 Prospects, Towner Art Gallery, Eastbourne

1992 *Women Critics' Choice of Women Artists*, Bruton Street Gallery, London

 Women's Art at New Hall, New Hall, Cambridge

 Whitechapel Open, Whitechapel Art Gallery, London

 Bruise: Painting for the 90s, Ikon Gallery, Birmingham;
 Cornerhouse, Manchester

 The Discerning Eye, Mall Galleries, London*

 (dis)parities, Mappin Art Gallery, Sheffield; Pomeroy Purdy Gallery, London;
 Herbert Art Gallery and Museum, Coventry*

 Heaven and Hell, Purdy Hicks Gallery, London

1991 *Allegories of Desire*, The Small Mansions Art Centre, London

 Art in Worship, Worcester Cathedral and Tewkesbury Abbey

 International Festival of Painting, Château Musée Grimaldi, Cagnes-sur-Mer
 (organized by the British Council)*

 Homage to the Square, Flaxman Gallery, London

 The Discerning Eye, Mall Galleries, London*

1990 *The Theory and Practice of the Small Painting*, Anderson O'Day Gallery, London

 Whitechapel Open, Whitechapel Art Gallery, London

1989 *Painters from Winchester*, The Winchester Gallery, Winchester

 Art and Nature, Flaxman Gallery, London*

1988 *Women and Water*, Odette Gilbert Gallery, London

 Gallery and Invited Artists, Pomeroy Purdy Gallery, London

1987 *A Green Thought in a Green Shade*, Richard Pomeroy Gallery, London

 Artists who Studied with Peter de Francia, Camden Arts Centre, London

SELECTED BIBLIOGRAPHY

Clare Stewart, 'Making an Impression', *The Times*, 31 March 2001

Paul Huxley, *The TI Group Art Collection*, catalogue, 2000

Richard Ingleby, 'Estelle Thompson', *The Independent*, 1 April 2000

Robert Clark, 'Prada goes green', *The Guardian*, April 2000

Ria Higgins, 'The Art of SE1', *The Sunday Times Magazine*, 7 May 2000

Hugh Stoddart, '% for Art: Milton Keynes Theatre and Art Gallery', *Public Arts Journal*, March 2000

William Packer, 'New home for a gifted collection', *The Financial Times*, 29 February 2000

Blue: Borrowed and New, exhib. cat., Walsall, The New Art Gallery Walsall, February 2000

Terry Grimley, 'No one's feeling blue at Walsall Art Gallery', *The Birmingham Post*, February 2000

Heather Neil, 'Exhibition: New Art Gallery Walsall', *Review*, February 2000

Alistair Hicks, 'Estelle Thompson: Beyond the Edge', *Antique Interiors International*, 34, 1999

William Packer, 'Estelle Thompson', *The Financial Times*, November 1999

Louisa Buck, Estelle Thompson, *The Art Newspaper*, November 1999

Tom Hammick, 'Art for Art's Sake', *The Observer*, 11 April 1999

'Know thy Friends', *RA* magazine, Summer 1998

Susan Wilson, 'The Weather for Painting', *AN Visual Arts*, March 1998

Estelle Thompson: Fuse Paintings, exhib. cat. by Anna Moszynska, Lincoln, Usher Gallery, *et al*., 1998

Simon Morley, 'Light as Surface', *Contemporary Art*, Autumn/Winter 1997

Andrew Lambirth, 'Purdy Hicks Profile', *Galleries/UK*, May 1997

Sandy Kitching, 'Contemporary British Art Shows', *Vision*, 1996–97

Dennis de Caires, edited transcript from a conversation with Estelle Thompson, London 1996

Estelle Thompson, exhib. cat. by Tony Godfrey, London, Purdy Hicks Gallery, 1996

Andrew Lambirth, 'Estelle Thompson', *What's On in London*, 2 October 1996

Sasha Craddock, 'Around the Galleries: New London Shows', *The Times*, 1 October 1996

Kate Miller, 'The Art of the Matter', *Harpers and Queen*, January 1995

Iain Gale, 'Making marks on the memory', *The Independent*, 11 January 1994

Alan Hatcher, 'Estelle Thompson', *Art Preview*, January 1994

Christopher Smith, 'All "paintings about painting"', *Eastbourne Herald*, 29 January 1994

Estelle Thompson, exhib. cat. by Paul Bonaventura and John Gillett, London, Purdy Hicks Gallery, 1993

Andrew Lambirth, 'Estelle Thompson', *RA* magazine, Autumn 1993

Sue Hubbard, 'Estelle Thompson', *Contemporary Art*, Autumn 1993

Charles Hall, 'No Head for Figures', *Art Review*, July/August 1993

Mark Sladen, '*Bruise*: Painting for the Nineties', *Frieze*, September/October 1992

Terry Grimley, ''Abstractions with a familiar look', The Birmingham Post, 24 July 1992

Tom Lubbock, 'Cruisin' for a bruisin' in Brum', *The Independent on Sunday*, 19 July 1992

Robert Clark, 'Bruise', *The Guardian*, 8 July 1992

Andy Tipper, 'Bruising the Canvas', *What's On in London*, July 1992

Robert Clark, 'Estelle Thompson', *The Guardian*, 9 June 1992

Sue Hubbard, 'Out of the ghetto?', *Galleries*, June 1999

Tim Hilton, 'Rising in the East End', *The Guardian*, 25 June 1992

Alistair Hicks, 'Young British Painters', *Antique and New Art*, Autumn 1991

Estelle Thompson, exhib. cat. by Mel Gooding, London, Pomeroy Purdy Gallery, 1991

Sue Hubbard, 'Estelle Thompson', *Time Out*, 2 October 1991

Iain Gale, 'Estelle Thompson', *Arts Review*, 20 September 1991

Luke Elwes, 'Luminous Icons', *Galleries*, September 1991

Sister Wendy Beckett, 'Art in Worship', *Arts Review*, September 1991

Tony Godfrey, 'A British Painting for the 90s', *Art in America*, April 1991

Estelle Thompson, exhib. cat. by Tony Godfrey, London, Pomeroy Purdy Gallery, 1989

Rose Jennings, 'Estelle Thompson', *City Limits*, November 1989

Mary Rose Beaumont, 'Estelle Thompson', *Arts Review*, October 1989

Sue Hubbard, 'Estelle Thompson', *Time Out*, 25 October 1989

Mark Currah, 'Art and Nature', *City Limits*, 3–10 August 1989

Sarah Kent, 'A Green Thought in a Green Shade', *Time Out*, 20–27 April 1988

Alistair Hicks, 'Vision and Illusion', *The Spectator*, 16 April 1989

Sarah Kent, 'Change in Art', *Time Out*, 6–13 January 1988

Mark Currah, 'Estelle Thompson', *City Limits*, January 1988

David Lee, 'Estelle Thompson', *Art Review*, December 1987

Tony Godfrey, 'Art Now: Budding Talents', Galleries, November 1987

Iain Gale, 'Estelle Thompson', *The Times*, 27 November 1987

Brian Hatton, 'Studio Artists/Richard Pomeroy', *Artscribe International*, Summer 1987

Mary Rose Beaumont, 'Landscape/Urbanscape', *Art Review*, February 1987

Monica Petzal, 'Landscape/Urbanscape', *Time Out*, 24 February – 4 March 1987

Mark Currah, 'Landscape/Urbanscape', *City Limits*, 12–19 February 1987

Brian Hatton, 'Studio Artists/Richard Pomeroy', *Artscribe International*, Summer 1986

EXHIBITION CATALOGUES

See also exhibitions marked with an asterisk (*) on page 118

2000 *Estelle Thompson*, exhib. cat, by Deborah Dean, Nottingham,
 Angel Row Gallery

1998 *Estelle Thompson: Fuse Paintings*, exhib. cat. by Anna Moszynska, Lincoln,
 Usher Gallery, *et al*.

1996 *Estelle Thompson*, exhib. cat. by Tony Godfrey, London, Purdy Hicks Gallery;
 Frankfurt, Galerie Helmut Pabst

1993 *Estelle Thompson*, exhib. cat. by Paul Bonaventura and John Gillett, London,
 Purdy Hicks Gallery, *et al.*

1991 *Estelle Thompson*, exhib. cat. by Mel Gooding, London, Pomeroy Purdy Gallery
 Estelle Thompson, exhib. cat. by Tony Godfrey, London, Pomeroy Purdy Gallery

AWARDS

1990 Prudential Award for the Arts 1990/Arts Council Special Award

1988 Royal Overseas League Travel Award

1983 Ethel Willis, Ethel Henriques and Fred Richards Memorial Travel Scholarship

COMMISSIONS

1999 Milton Keynes Theatre, Milton Keynes

1993 Quaglino's Restaurant, St James's, London. Column painting commissioned
 by Sir Terence Conran

COLLECTIONS

Arts Council of Great Britain

British Museum, London

Contemporary Art Society

Towner Art Gallery, Eastbourne

Abbot Hall Art Gallery, Kendal

De Montfort University, Leicester

University of Warwick

British Council

Chelsea & Westminster Hospital, London

New Hall College, Cambridge

Ferens Art Gallery, Hull

Oldham Art Gallery

The New Art Gallery Walsall

New York Public Library

Arthur Andersen & Co

Coopers & Lybrand

Credit Suisse First Boston

Deutsche Bank

Eversheds, Birmingham

Pearl Assurance

Reed International

TI Group plc

British Midland

County Natwest

De Beers Consolidated Mines Ltd

The Economist Group

Goldman Sachs

Pearson plc, New York

Reynolds Porter Chamberlain

Unilever plc